DRAW IT YOURSELF

TONY HART

© 1989 Tony Hart

To Judy & George Martin

Cover portrait by Philip Nunn

British Library Cataloguing in Publication Data
Hart, Tony, *1925-*
 Draw it yourself.
 1. Drawings. Techniques -- For children
 I. Title
 741.2

ISBN 1 - 85219 - 038 - 8

All enquiries and requests relevant to this title
should be sent to the publisher, Bishopsgate Press
Ltd., 37 Union Street, London SE1 1SE

Printed in Great Britain by The Bath Press, Avon

INTRODUCTION

'Draw it Yourself' has been designed as a practical drawing and painting book. It follows a method used by most cartoonists who make a rough pencil drawing before committing themselves to the pen. This enables the artist to see if the basic drawing is satisfactory before going over the right lines with a pen or marker. Pencil lines can always be rubbed out later. The rough drawings are usually very simple shapes which give indication as to the form of whatever you are drawing. Circles, half circles, squares and triangles make excellent basis for cartoon drawing. They can be quite rough and ready, not so geometrically neat as I've shown at the bottom of these pages. Just try to give yourself a lightly drawn pencil guide as to the overall shape of your subject made up of the different shapes you need. Look again at the progression of shapes I've made and you'll see just what I mean.

Very young children are often given cut out shapes which they can put together or put them into the correct hole of the same shape. These sometimes bring about simple pictures and this is what we are doing to make the basis of our drawings. There are 30 projects in this book, all of which show those shapes required to make a basic drawing, then the way they can be put together and finally my own idea as to how the cartoon could be finished off. You may have other ideas as to detail and so forth. We are thinking in terms of black and white drawing to start with but later on we can see how colour may be used as well.

The youngest children may like to colour my finished pictures or draw and paint whatever they wish on the drawing page provided. Others will copy my drawings or start from scratch using the 'Shapes' method of working out the basis, pencilling in the rough drawing and finally making their own finished work. Whatever you do, however young or old you may be, I hope that you will find the book useful and fun and that you 'Draw it Yourself'.

You require very few drawing materials for the sort of artwork shown in this book. For the black and white illustrations only a pencil, pen, rubber and paper are needed. When we come to colour, and I assume that we are going to colour the pen and ink drawings, both dry and wet colour can be used. Water colour or ink. Paint sticks, crayons and pastels are all fine. Let's take a look at some of them.

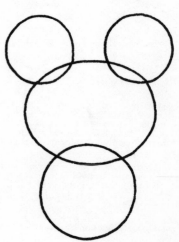

MATERIALS

PAPER

The paper in this book is of good quality and those pages opposite each drawing project will be suitable for any of these media. Just remember that some spirit-based marker pens will penetrate any paper and should only be used on thick card. I haven't used any of these for the artwork here. You will, of course, soon use up the drawing pages here and require more paper. You will find paper similar to these pages in a pad form at stationers or Art Supply shops. These come in sizes ranging from A1 to A5. These pages are A4. You can also buy sheets of cartridge paper singly. These are usually very large and can be cut to size.

PENCILS

'B' means soft, 'H' means hard. The most useful for our purpose is a 2B. It's soft enough to erase easily without leaving marks.

ERASERS

Use the rubber you like, or you might like to try a kneadable Putty Rubber. These can be shaped to a point for delicate work and also pick up all the bits.

PENS

For this work use one of those drawing pens that come in a range of sizes from 0.1 to 0.8. Here are three makes which you will find very good. Edding 1800 Profipen, Pilot DR Drawing Pen and Artline Drawing System. All these are permanent and can take a colour wash. The ink will not run, neither will the ink penetrate the paper.

COLOUR INKS

Rotring Artists Colour, DRG Royal Sovereign Magic Color and Pebeo Colorex are all good. The Colorex inks are transparent and soluble in water. I have used these for all the colour work in the book.

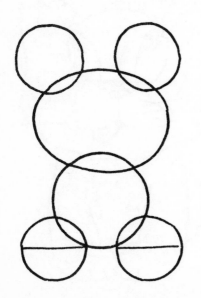 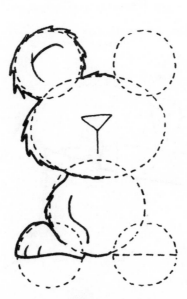 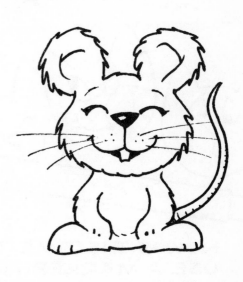

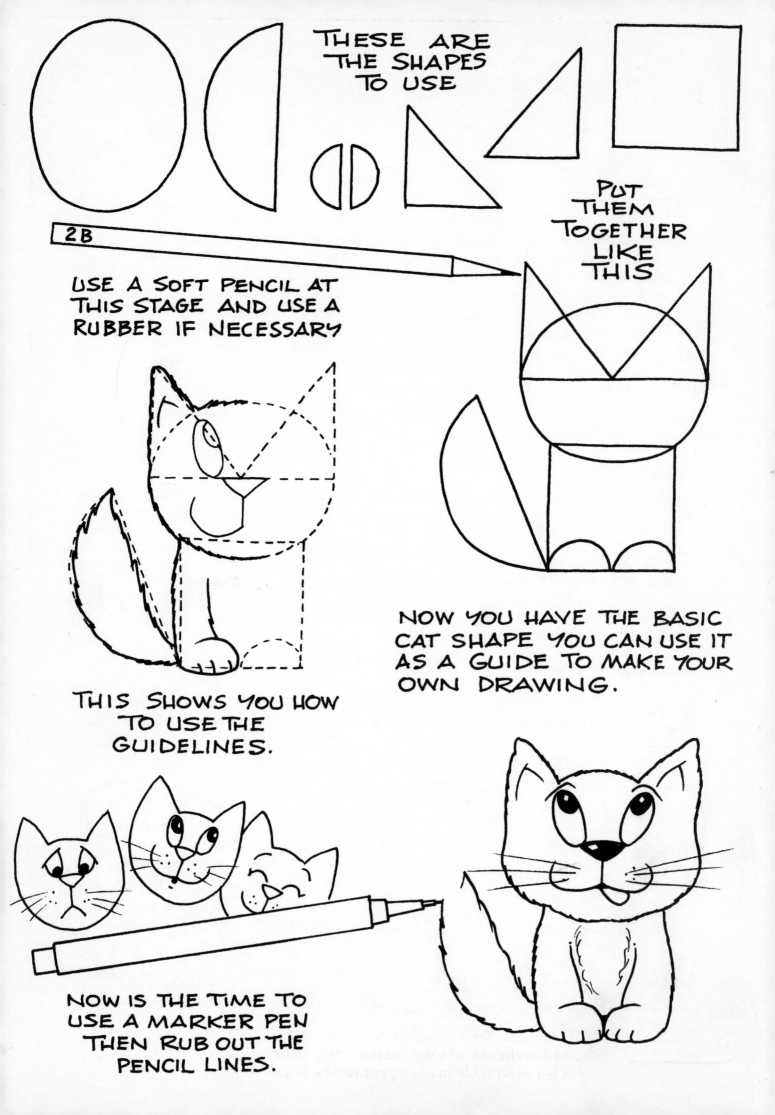

THESE ARE THE SHAPES TO USE

2B

PUT THEM TOGETHER LIKE THIS

USE A SOFT PENCIL AT THIS STAGE AND USE A RUBBER IF NECESSARY

NOW YOU HAVE THE BASIC CAT SHAPE YOU CAN USE IT AS A GUIDE TO MAKE YOUR OWN DRAWING.

THIS SHOWS YOU HOW TO USE THE GUIDELINES.

NOW IS THE TIME TO USE A MARKER PEN THEN RUB OUT THE PENCIL LINES.

USE THIS PAGE FOR YOUR DRAWINGS
Remember the ink of some markers may penetrate this paper.
A list of suitable marker pens can be found on page 3.

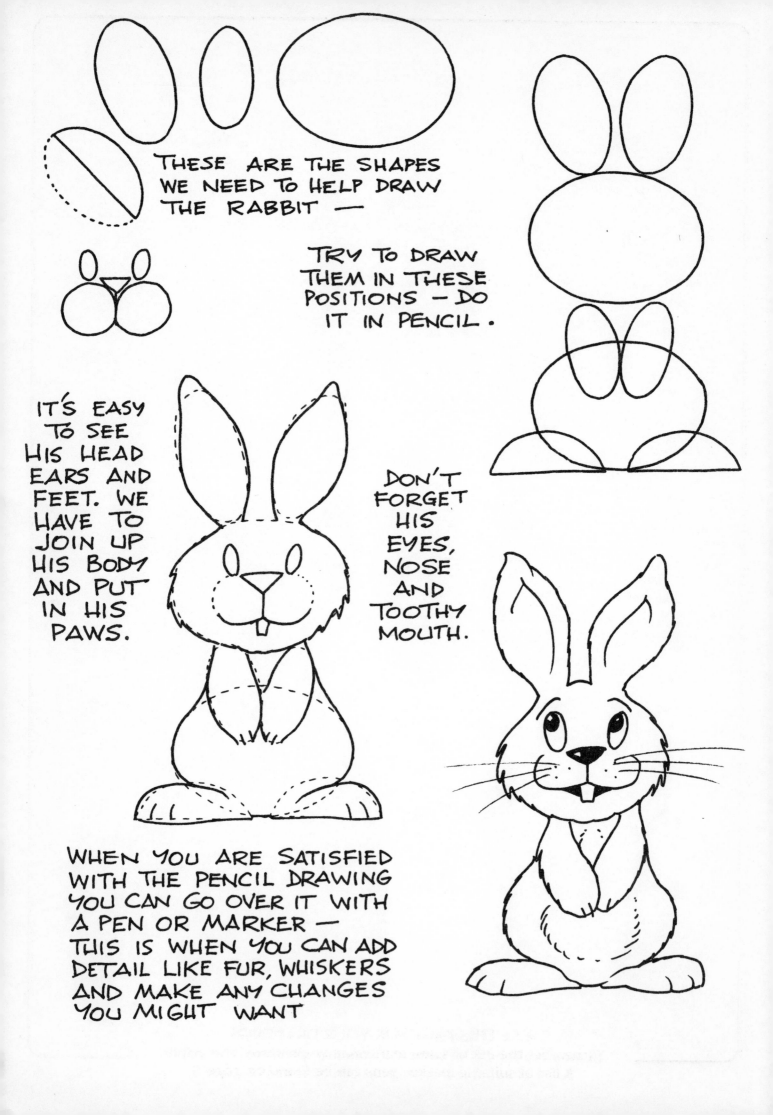

THESE ARE THE SHAPES WE NEED TO HELP DRAW THE RABBIT —

TRY TO DRAW THEM IN THESE POSITIONS — DO IT IN PENCIL.

IT'S EASY TO SEE HIS HEAD EARS AND FEET. WE HAVE TO JOIN UP HIS BODY AND PUT IN HIS PAWS.

DON'T FORGET HIS EYES, NOSE AND TOOTHY MOUTH.

WHEN YOU ARE SATISFIED WITH THE PENCIL DRAWING YOU CAN GO OVER IT WITH A PEN OR MARKER — THIS IS WHEN YOU CAN ADD DETAIL LIKE FUR, WHISKERS AND MAKE ANY CHANGES YOU MIGHT WANT

USE THIS PAGE FOR YOUR DRAWINGS
Remember the ink of some markers may penetrate this paper.
A list of suitable marker pens can be found on page 3.

THE HIPPOPOTAMUS JUST NEEDS THESE THREE SHAPES TO FORM HIS BODY. DRAW THEM LIKE THIS AND YOU'LL FIND IT EASY TO ADD THE OTHER FEATURES.

ALWAYS DRAW WITH PENCIL FIRST SO YOU CAN SEE ALL THE SHAPES. ONLY WHEN YOU'RE SATISFIED YOU'VE GOT THE RIGHT LINES GO OVER THEM WITH A PEN. PENCIL MARKS CAN BE EASILY RUBBED OUT.

THE BIRD IS BASED ON A TEAR-DROP SHAPE.

CAN YOU IMAGINE WHERE THE OVAL SHAPES WOULD BE DRAWN TO HELP MAKE THESE HIPPOS?

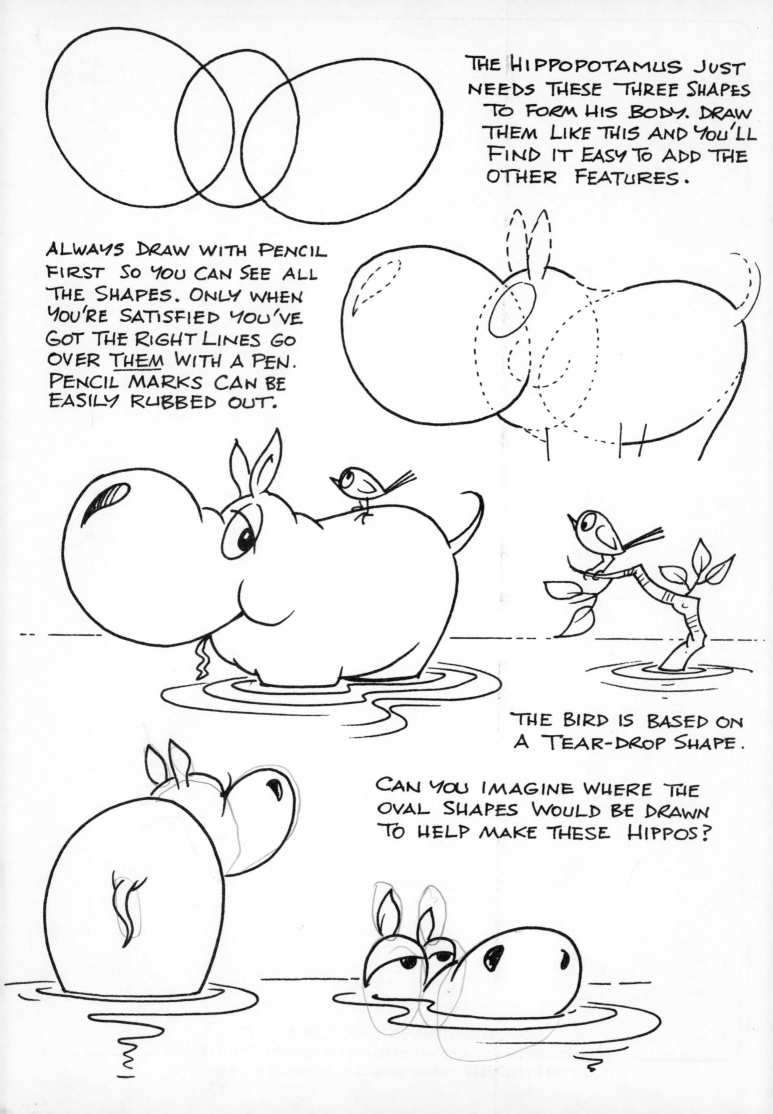

USE THIS PAGE FOR YOUR DRAWINGS
Remember the ink of some markers may penetrate this paper.
A list of suitable marker pens can be found on page 3.

DRAW A BIG CIRCLE USING A SOFT (2B) PENCIL. NOW DRAW THE OTHER SHAPES AS THEY ARE SHOWN HERE

THESE SHAPES ARE HALVES OF THIS ONE

DON'T WORRY IF YOU GET IT WRONG FIRST TIME YOU CAN RUB IT OUT AND DO IT AGAIN. WHEN YOU ARE SATISFIED THAT YOU HAVE GOT IT RIGHT START PUTTING MORE DETAIL IN.

NOW IT'S STARTING TO LOOK LIKE A TORTOISE. WORK OUT WHERE THE MARKINGS GO ON HIS SHELL.

TIME TO USE A PEN IF YOU WANT TO. GO OVER THE RIGHT PENCIL LINES AND PUT IN ANYTHING ELSE YOU WANT.

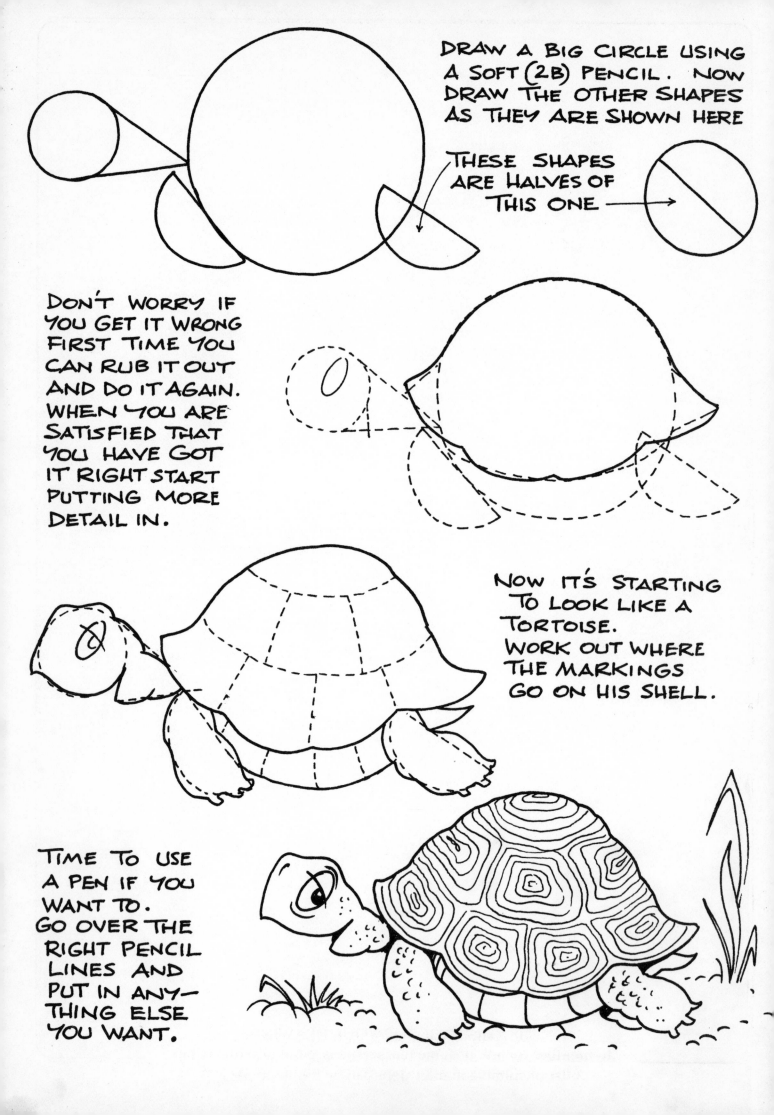

USE THIS PAGE FOR YOUR DRAWINGS
Remember the ink of some markers may penetrate this paper.
A list of suitable marker pens can be found on page 3.

THE PONY IS MADE UP FROM THESE SHAPES – ONE LIKE A MATCHBOX, TWO CIRCLES, ONE SMALLER THAN THE OTHER AND TWO TRIANGLES.

DRAW THEM LIKE THIS

USE A SOFT PENCIL FIRST SO YOU CAN RUB THOSE LINES OUT LATER

DRAW HIS SHAGGY COAT OVER THE SQUARE BODY AREA.

SEE HOW THE FEET FIT INTO THE TRIANGLES!

THE EYES AND MOUTH CAN BE DRAWN TO ALTER THE EXPRESSION.

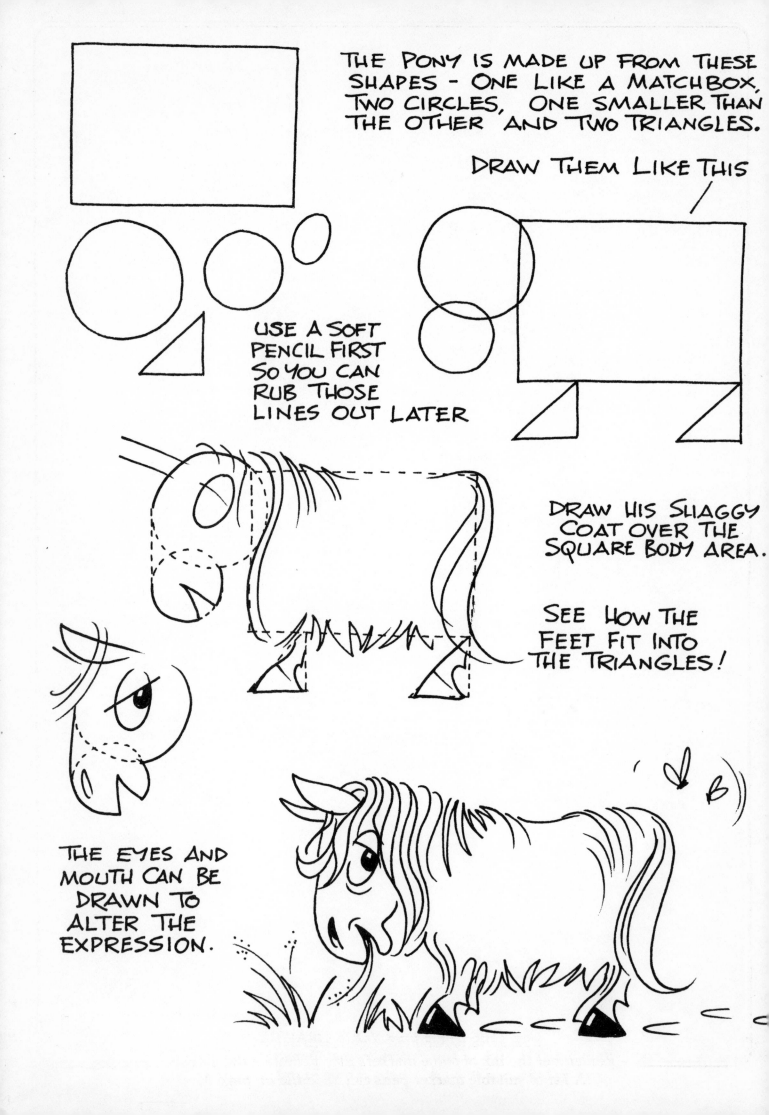

USE THIS PAGE FOR YOUR DRAWINGS
Remember the ink of some markers may penetrate this paper.
A list of suitable marker pens can be found on page 3.

FIRST DRAW A LARGE OVAL
SHAPE FOR THE PIG'S BODY —

NOW DRAW
THESE SHAPES
TO MAKE HIS
FACE

HE NEEDS AN EYE AND A TAIL!

SEE HOW TWO TINY
TRIANGLES LOOK LIKE
LEGS AND FEET. THEY
ALSO MAKE THE PIG
LOOK MUCH FATTER.

DRAW THE CURLY
TAIL IN TWO PARTS
LIKE THIS

YOU COULD DRAW
TWO PIGS — ONE
HAPPY — AND ONE RATHER CROSS!

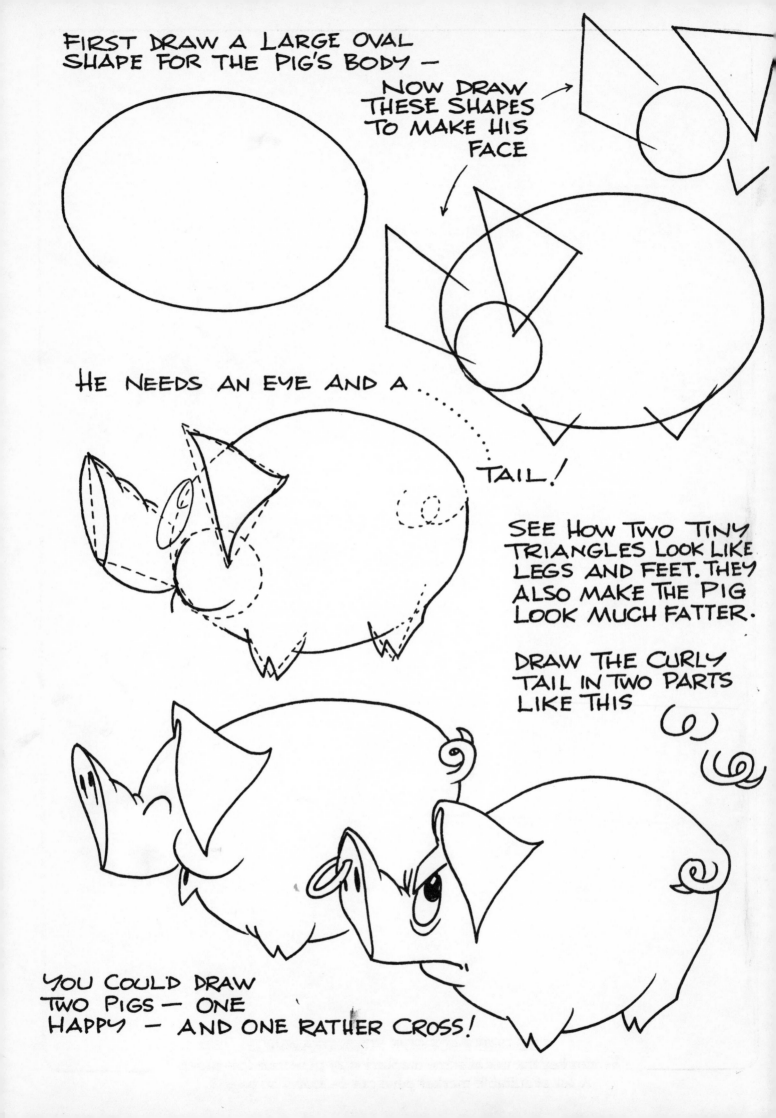

USE THIS PAGE FOR YOUR DRAWINGS
Remember the ink of some markers may penetrate this paper.
A list of suitable marker pens can be found on page 3.

EGG SHAPES ARE USEFUL - THEY'RE EASIER TO DRAW IF YOU MAKE A CIRCLE FIRST. THE PENGUIN IS MADE UP FROM THESE.

NOTE THE LARGE EGG-SHAPE OF THE BODY HAS ANOTHER EGG SHAPE IN IT. THIS SHOWS CLEARLY WHERE THE PENGUIN IS WHITE. THE REST IS BLACK.

THE CURVE IN HIS BEAK MAKES HIM SMILE!

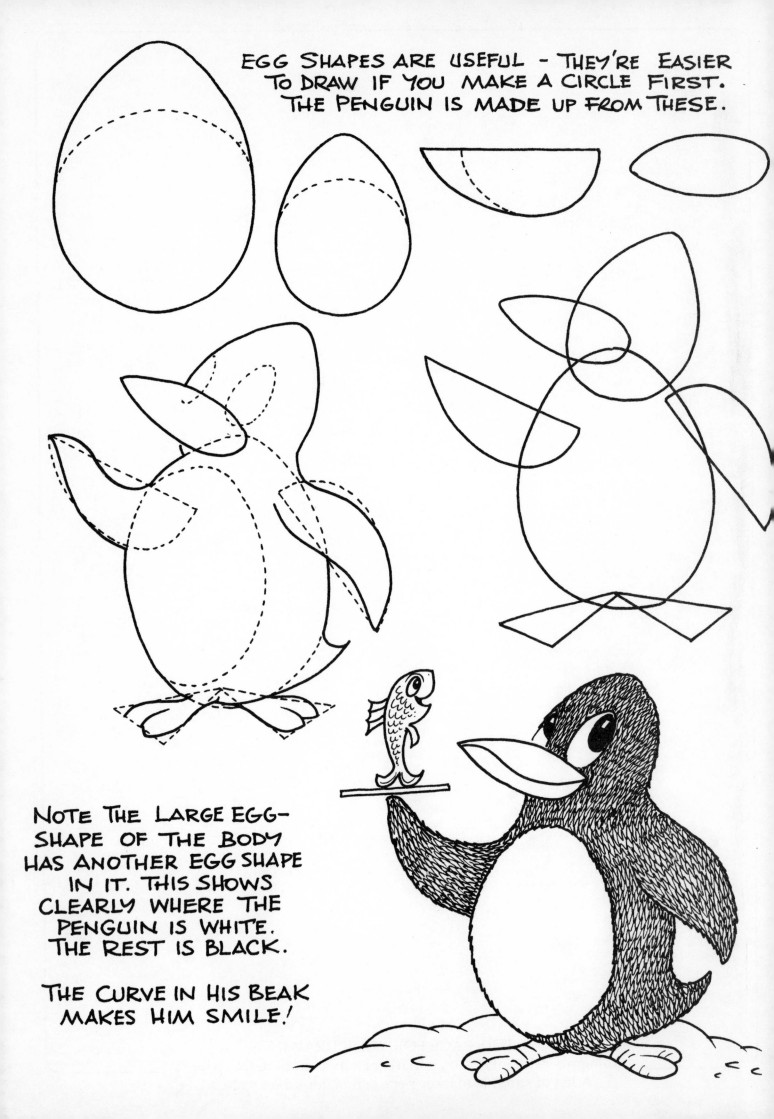

USE THIS PAGE FOR YOUR DRAWINGS
Remember the ink of some markers may penetrate this paper.
A list of suitable marker pens can be found on page 3.

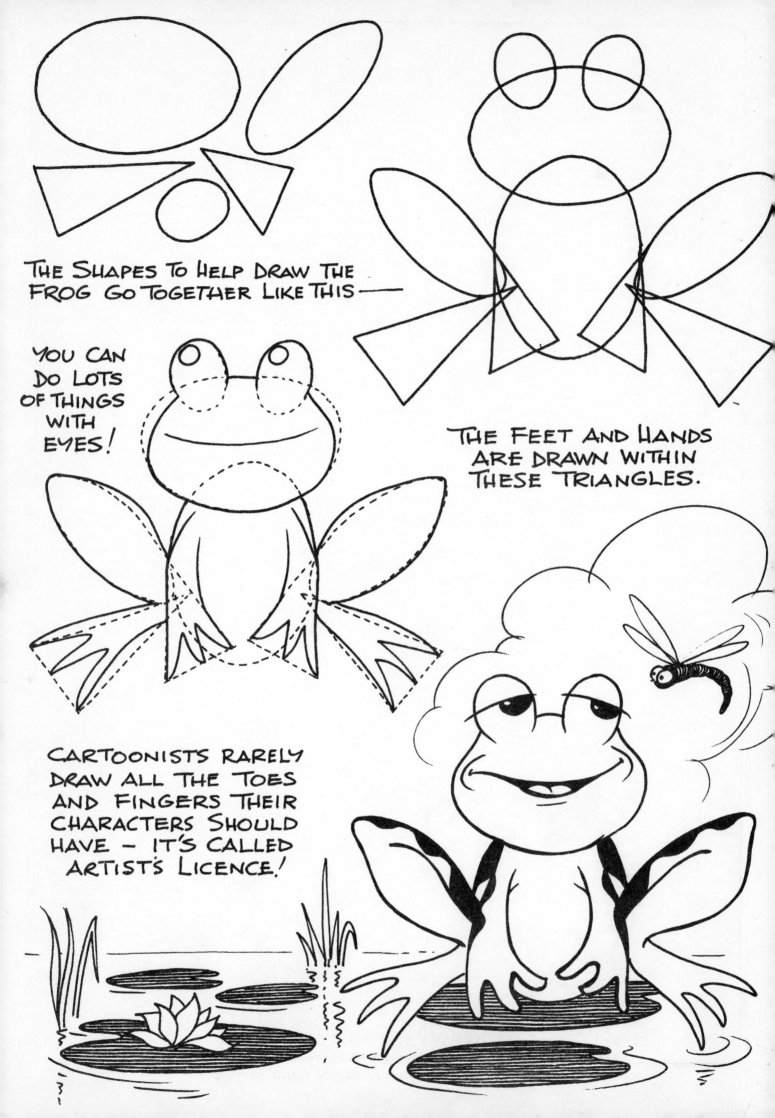

THE SHAPES TO HELP DRAW THE
FROG GO TOGETHER LIKE THIS —

YOU CAN
DO LOTS
OF THINGS
WITH
EYES!

THE FEET AND HANDS
ARE DRAWN WITHIN
THESE TRIANGLES.

CARTOONISTS RARELY
DRAW ALL THE TOES
AND FINGERS THEIR
CHARACTERS SHOULD
HAVE — IT'S CALLED
ARTIST'S LICENCE!

USE THIS PAGE FOR YOUR DRAWINGS
Remember the ink of some markers may penetrate this paper.
A list of suitable marker pens can be found on page 3.

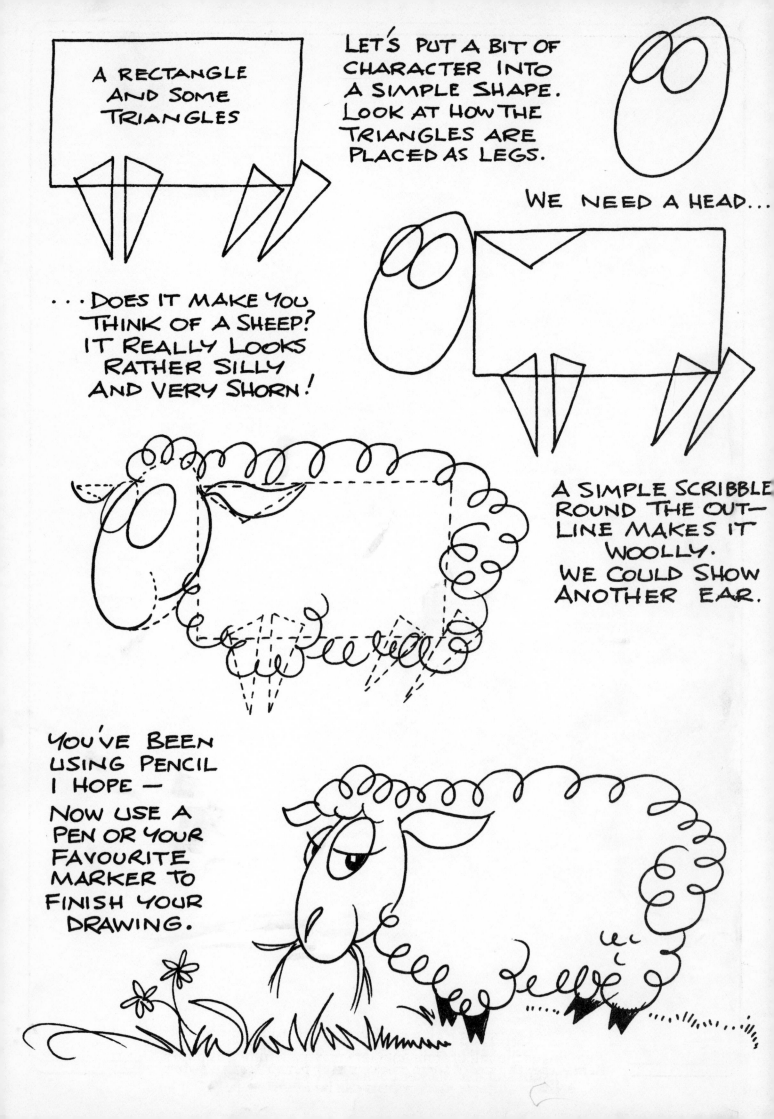

A RECTANGLE AND SOME TRIANGLES

LET'S PUT A BIT OF CHARACTER INTO A SIMPLE SHAPE. LOOK AT HOW THE TRIANGLES ARE PLACED AS LEGS.

WE NEED A HEAD...

...DOES IT MAKE YOU THINK OF A SHEEP? IT REALLY LOOKS RATHER SILLY AND VERY SHORN!

A SIMPLE SCRIBBLE ROUND THE OUTLINE MAKES IT WOOLLY. WE COULD SHOW ANOTHER EAR.

YOU'VE BEEN USING PENCIL I HOPE —

NOW USE A PEN OR YOUR FAVOURITE MARKER TO FINISH YOUR DRAWING.

USE THIS PAGE FOR YOUR DRAWINGS
Remember the ink of some markers may penetrate this paper.
A list of suitable marker pens can be found on page 3.

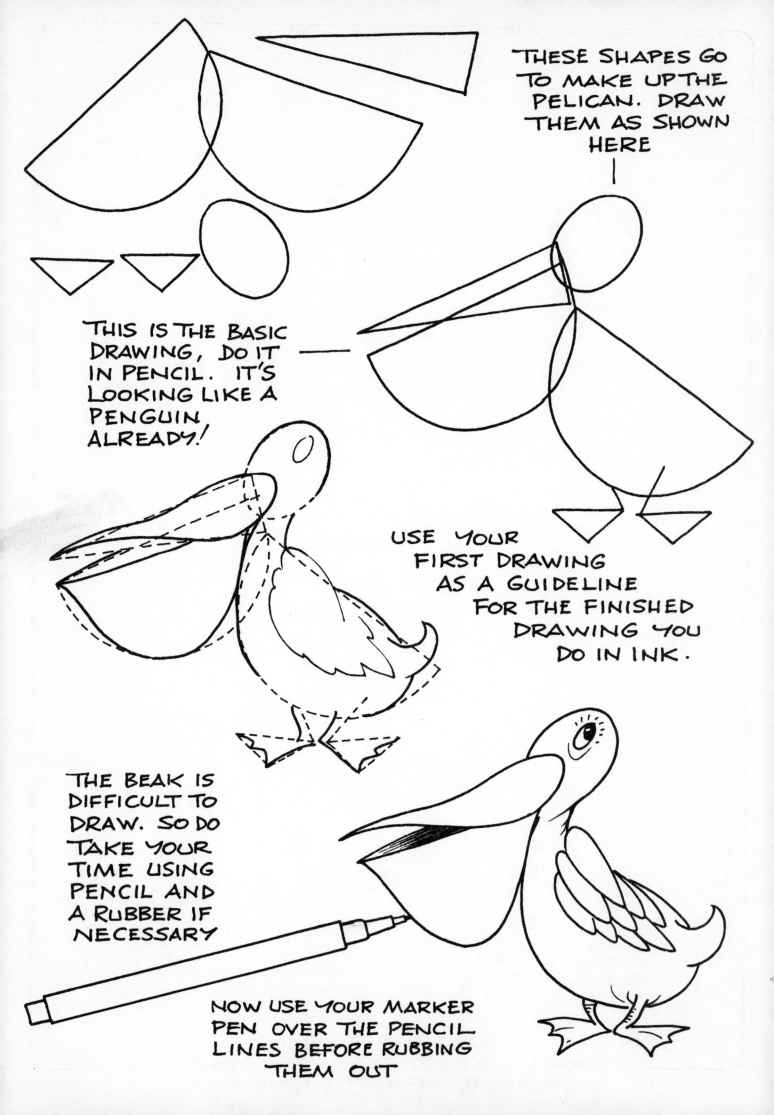

THESE SHAPES GO TO MAKE UP THE PELICAN. DRAW THEM AS SHOWN HERE

THIS IS THE BASIC DRAWING, DO IT IN PENCIL. IT'S LOOKING LIKE A PENGUIN ALREADY!

USE YOUR FIRST DRAWING AS A GUIDELINE FOR THE FINISHED DRAWING YOU DO IN INK.

THE BEAK IS DIFFICULT TO DRAW. SO DO TAKE YOUR TIME USING PENCIL AND A RUBBER IF NECESSARY

NOW USE YOUR MARKER PEN OVER THE PENCIL LINES BEFORE RUBBING THEM OUT

USE THIS PAGE FOR YOUR DRAWINGS
Remember the ink of some markers may penetrate this paper.
A list of suitable marker pens can be found on page 3.

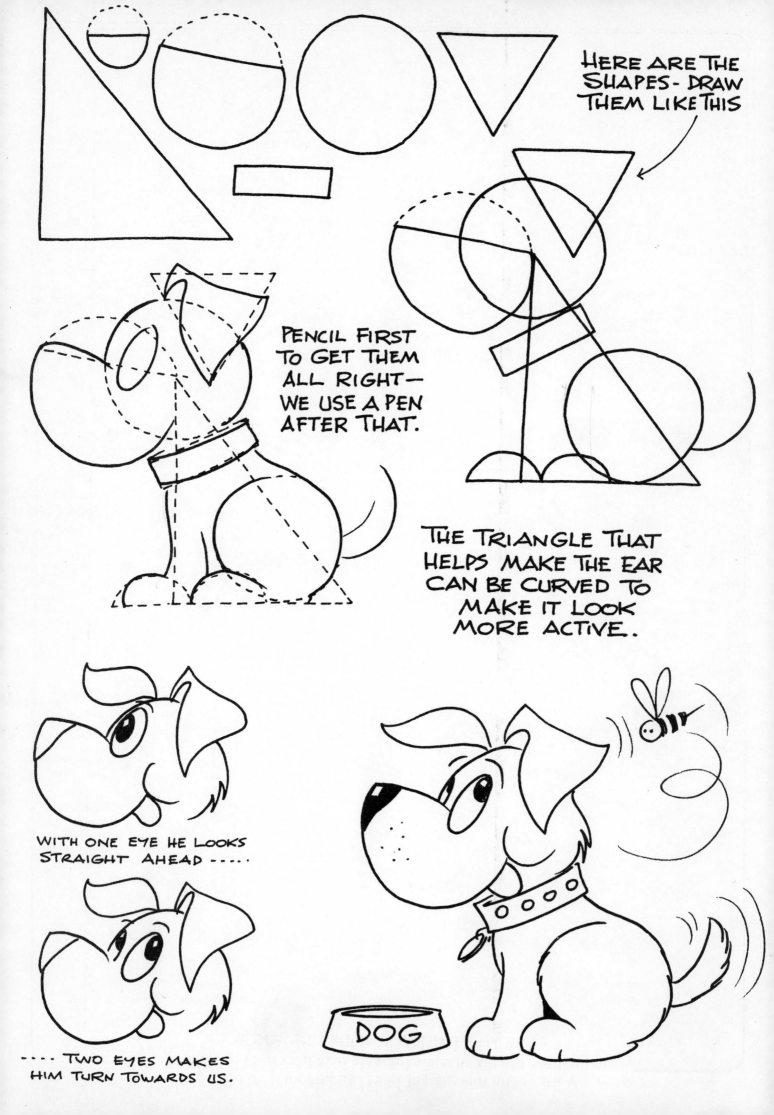

HERE ARE THE SHAPES - DRAW THEM LIKE THIS

PENCIL FIRST TO GET THEM ALL RIGHT— WE USE A PEN AFTER THAT.

THE TRIANGLE THAT HELPS MAKE THE EAR CAN BE CURVED TO MAKE IT LOOK MORE ACTIVE.

WITH ONE EYE HE LOOKS STRAIGHT AHEAD ·····

····· TWO EYES MAKES HIM TURN TOWARDS US.

DOG

USE THIS PAGE FOR YOUR DRAWINGS
Remember the ink of some markers may penetrate this paper.
A list of suitable marker pens can be found on page 3.

THE SEA LION IS MADE UP OF CURVES BUT THESE SHAPES WILL HELP YOU.

DRAW EVERYTHING IN PENCIL FIRST.
DRAW THE CURVES IN OR OVER THE TRIANGLES AND OTHER SHAPES.

A RATHER DIFFICULT SHAPE IS THIS ONE IT HELPS TO DRAW THE BOX SHAPE FIRST.

ALL PENCIL MARKS CAN BE RUBBED OUT AFTER YOU'VE INKED OVER YOUR WORK.

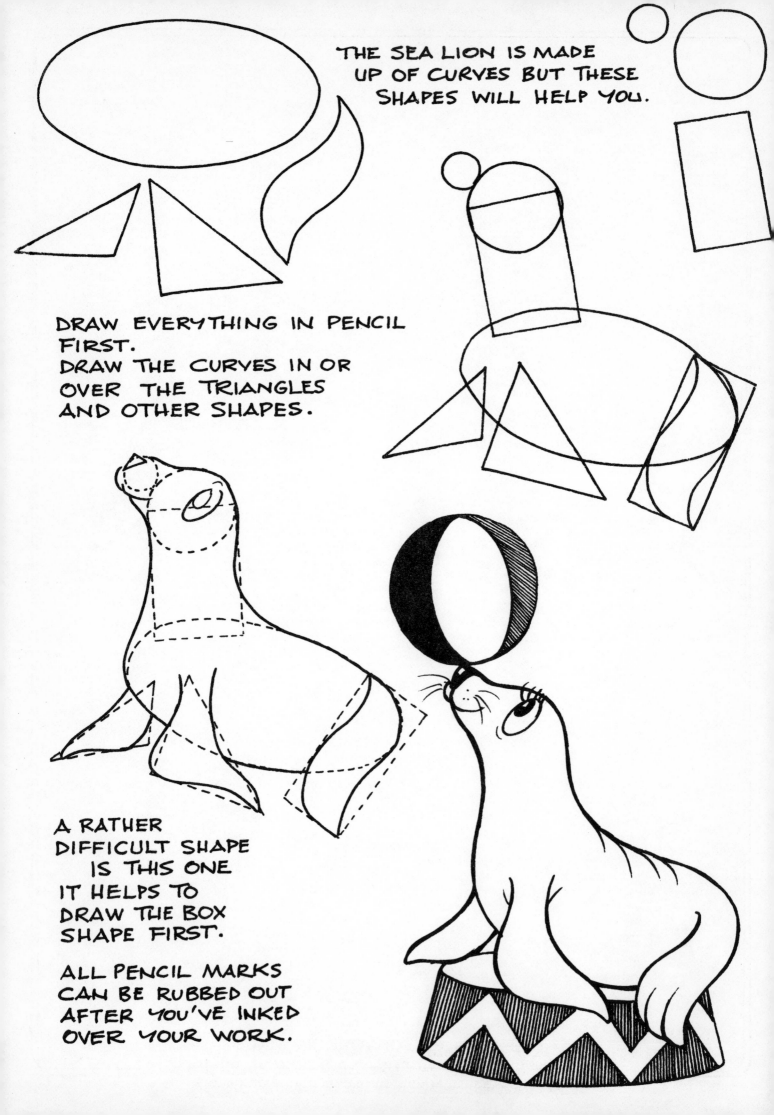

USE THIS PAGE FOR YOUR DRAWINGS
Remember the ink of some markers may penetrate this paper.
A list of suitable marker pens can be found on page 3.

DRAW THESE SHAPES FIRST....

...THE NECK AND HEAD NEEDS TO BE PLACED LIKE THIS

ALL THE EGG SHAPES WILL HELP YOU GET THE BODY, THIGH AND FEATHERS IN THE RIGHT PLACE.

AN OSTRICH HAS VERY BIG FEET!

YOU CAN GIVE YOUR OSTRICH WHATEVER EXPRESSION YOU LIKE.

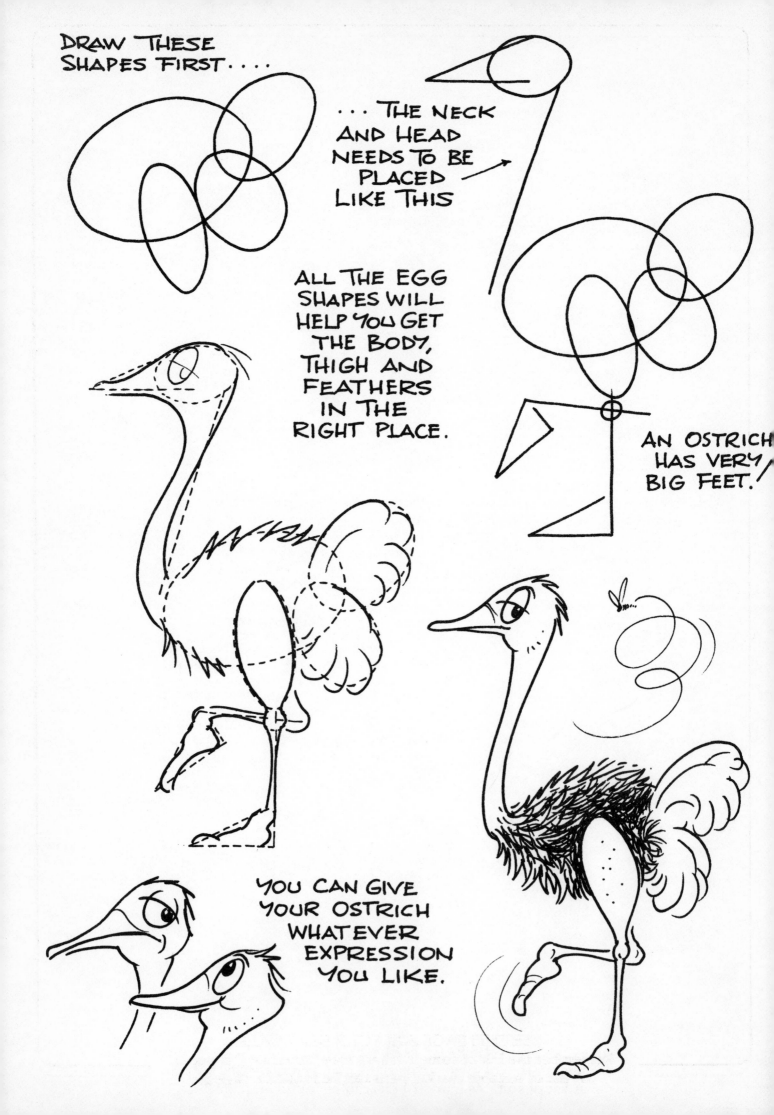

USE THIS PAGE FOR YOUR DRAWINGS
Remember the ink of some markers may penetrate this paper.
A list of suitable marker pens can be found on page 3.

THREE EASY SHAPES AND THIS RATHER DIFFICULT ONE ——→ IT'S CALLED A HELIX.

WE ARE GOING TO DRAW A SNAIL.

START OFF LIKE THIS.

USE YOUR FIRST PENCIL DRAWING AS A BASIS FOR MORE DETAIL AS SHOWN HERE.

SNAILS DO NOT HAVE EYES LIKE THIS BUT WE OFTEN GIVE OTHER CREATURES HUMAN CHARACTERISTICS WHEN WE DRAW CARTOONS OF THEM.

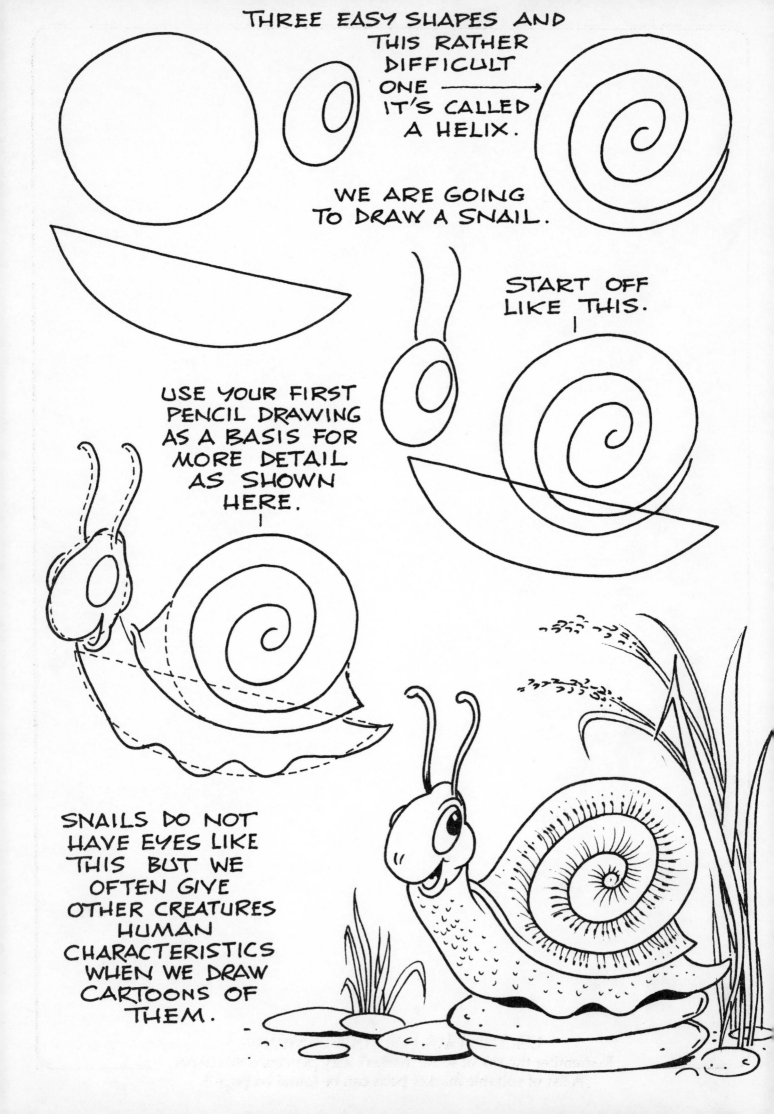

USE THIS PAGE FOR YOUR DRAWINGS
Remember the ink of some markers may penetrate this paper.
A list of suitable marker pens can be found on page 3.

We are at a halfway stage of the book. I hope you've been enjoying your drawing and, perhaps, adapting my ideas to make your own pictures. It's surprising how useful these basic shapes can be.

The colour pages show what a difference water colour, crayon and inks can make to your work when it's been drawn in black and white. A tip about coloured inks, some are not soluble in water; they tend to disintergrate into specks of sediment and will ruin the picture. These inks should not be mixed with water. Other inks will mix with water and each other. See page 3 for suggested materials.

You will have realized that all my drawings have been made in black and white and have been made with single pen strokes and marks. A sort of grey area can be achieved by hatching. This means drawing thin, close lines over the whole area you want to fill with this tone. Tone value means the lightness and darkness of what you draw. My three bears are identical but have different tone values. With colour I wouldn't have needed to do any hatching. I could colour each bear with different tone values of colour or different colours. Colouring over the hatched area darkens the colour as you can see on the tub on which the sealion sits. Note the difference between the ball on his nose in the two drawings.

Another fascinating way of producing soft colours and one that imitates the airbrush is to use coloured chalks or pastels. You rub the chalk on a piece of card or paper until you collect enough of the coloured dust for your needs. This is applied to the drawing with cotton wool. Paper masks cut to fit over those parts of your drawing you don't want coloured will protect those areas. The whole process is illustrated on page 34. You can mix these soft colours together producing pleasant effects. They also set off the subject of your drawing. Compare the first and last picture of the pelican over the page.

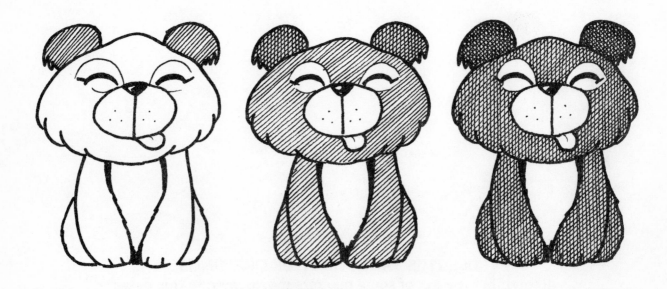

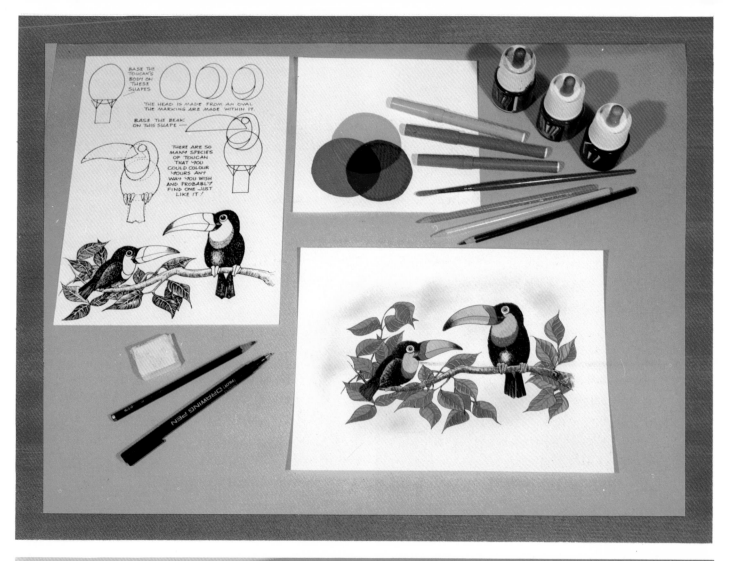

BASE THE
TOUCAN'S
BODY ON
THESE
SHAPES

THE HEAD IS MADE FROM AN OVAL
THE MARKING ARE MADE WITHIN IT.

BASE THE BEAK
ON THIS SHAPE —

THERE ARE SO
MANY SPECIES
OF TOUCAN
THAT YOU
COULD COLOUR
YOURS ANY
WAY YOU WISH
AND PROBABLY
FIND ONE JUST
LIKE IT!

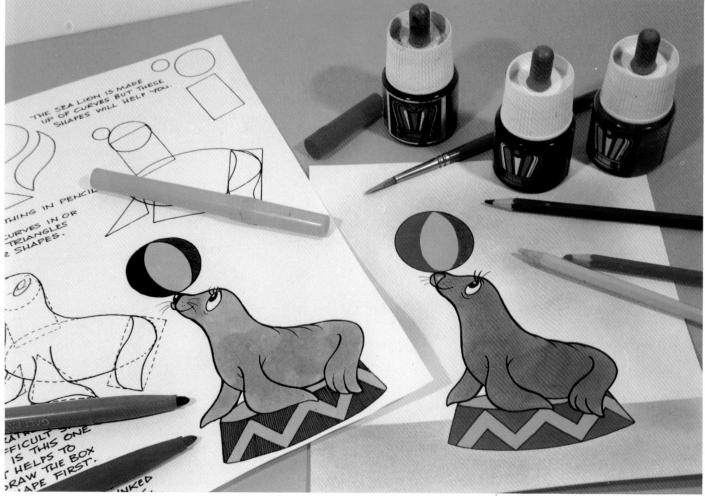

THE SEA LION IS MADE
UP OF CURVES BUT THESE
SHAPES WILL HELP YOU.

...THING IN PENCIL

...CURVES IN OR
...TRIANGLES
...2 SHAPES.

...EATACLY
...FFICULT 5
...T IS THIS ONE
...T HELPS TO
...DRAW THE BOX
...APE FIRST.

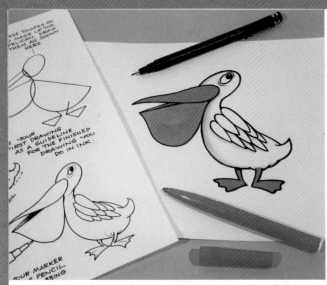
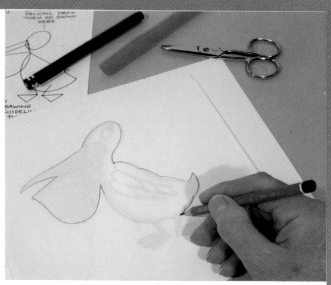

1. The pelican, drawn with a pen, has been coloured with an orange paint stick.

2. Detail paper over the drawing shows enough for the outline to be traced with pencil.

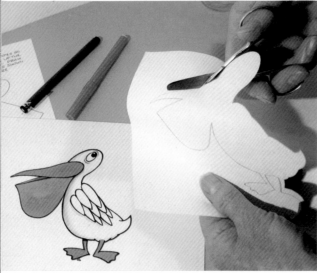
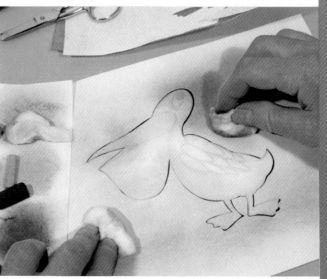

3. The outline is cut out in one piece with scissors or a craft knife.

4. The mask prevents the pelican from being marked by the powdered cotton wool.

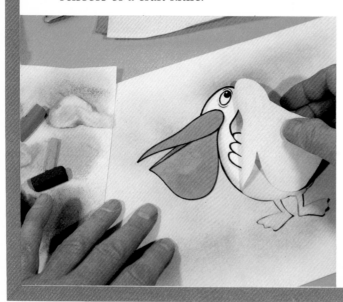
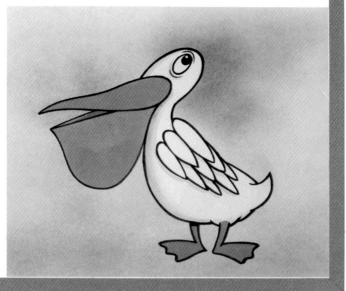

5. Hard and soft edges are shown when you remove the masking paper.

6. This method is good for showing up subjects with large areas of white in them.

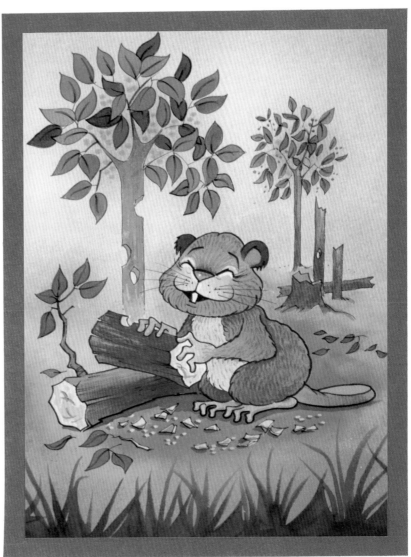

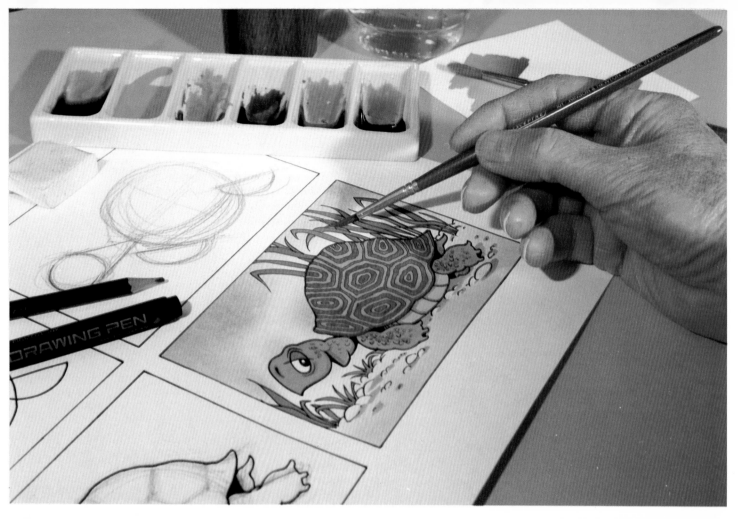

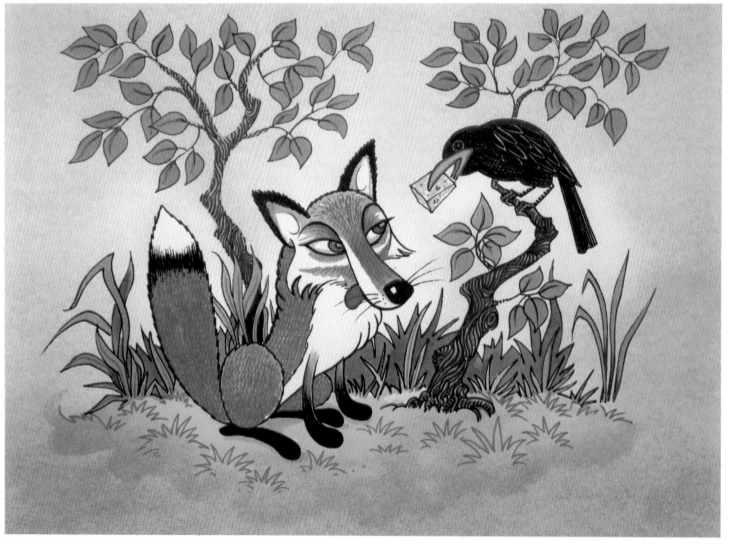

You will have seen that most of the animal drawings in this book are of the cartoon type. They are fun to draw and so many people I talk with are keen on drawing in this way. Hopefully, you will find it easier now to draw your own version of these characters but based on the shapes that form the basis. It's fun, I know, to copy cartoons from your favourite strips and TV shows but even more to create your own.

The basic shape method can apply equally well to less 'Cartoony' creations as I've shown opposite with the Fox and the Crow. (*see* page 64 for the black and white version). The tortoise is almost a cartoon in reality! I'm showing some of the stages of construction to the colouring of the black and white work.

The background of any subject can add more interest or show the subject to advantage. Look at the crocodile on page 40. The contrast of black and white. The same goes for the elephant on page 50. It applies also to the colour version on the cover. There too you'll see colour used realistically, as with the elephant but less so with the bear; interesting colour combinations which all add to the scheme of things. Colour can also bring about different moods as well as effects; greens and blues are cool colours while reds and yellows are warm.

Realism has been applied to one of the kangaroo drawings on page 42. It's always useful to be aware of the actual shape of animals whether you decide to draw it how it is or in your own cartoon way. The Bush Baby on page 62 is a compromise. Giving human characteristics to animals is called Anthropomorphism — almost as hard to say as to spell — so it's interesting to compare Walt Disney's Mickey Mouse with a real mouse or my cartoon snail with a real one. It's nearly always the humanised expression that makes us feel closer to the character.

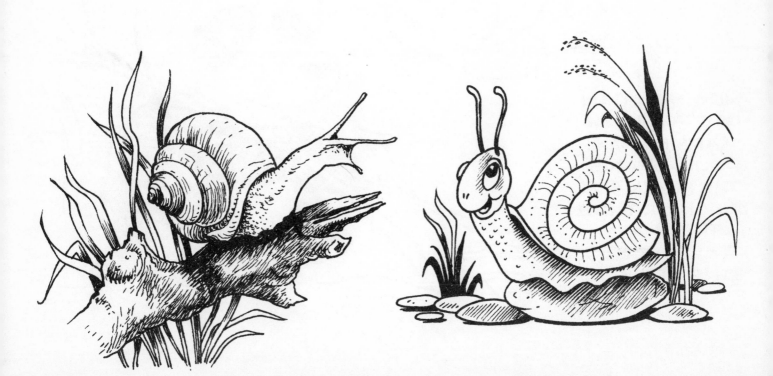

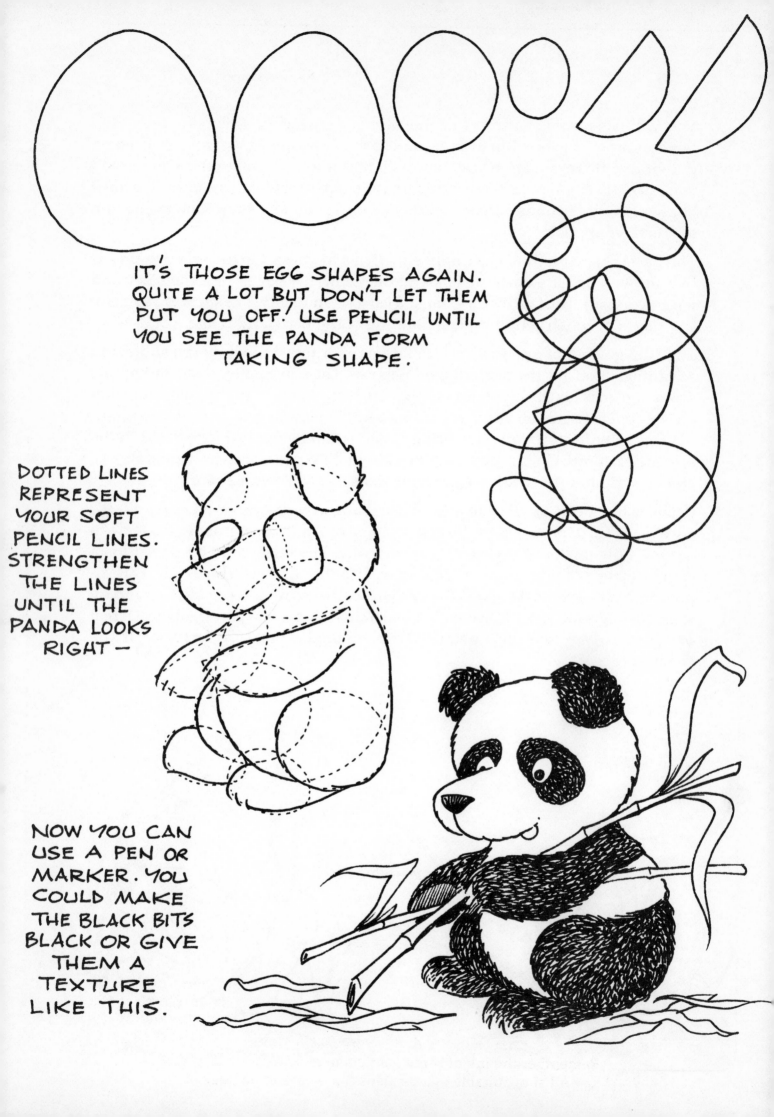

IT'S THOSE EGG SHAPES AGAIN.
QUITE A LOT BUT DON'T LET THEM
PUT YOU OFF! USE PENCIL UNTIL
YOU SEE THE PANDA FORM
TAKING SHAPE.

DOTTED LINES
REPRESENT
YOUR SOFT
PENCIL LINES.
STRENGTHEN
THE LINES
UNTIL THE
PANDA LOOKS
RIGHT —

NOW YOU CAN
USE A PEN OR
MARKER. YOU
COULD MAKE
THE BLACK BITS
BLACK OR GIVE
THEM A
TEXTURE
LIKE THIS.

USE THIS PAGE FOR YOUR DRAWINGS
Remember the ink of some markers may penetrate this paper.
A list of suitable marker pens can be found on page 3.

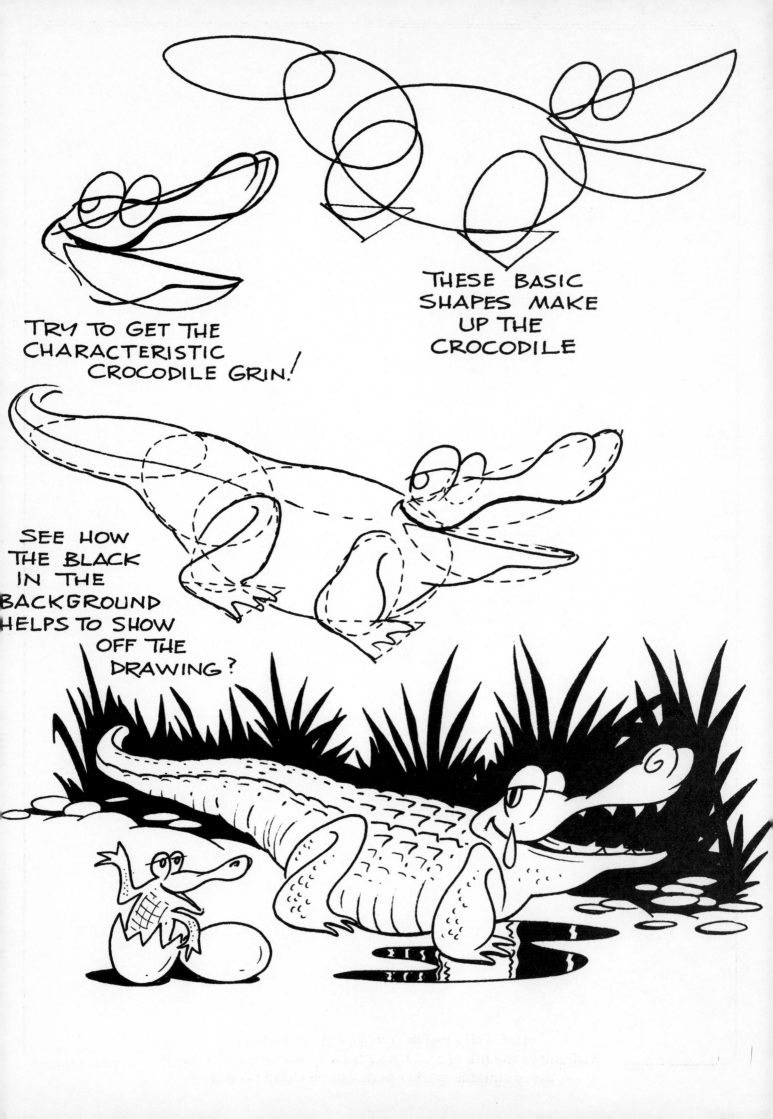

TRY TO GET THE CHARACTERISTIC CROCODILE GRIN!

THESE BASIC SHAPES MAKE UP THE CROCODILE

SEE HOW THE BLACK IN THE BACKGROUND HELPS TO SHOW OFF THE DRAWING?

USE THIS PAGE FOR YOUR DRAWINGS
Remember the ink of some markers may penetrate this paper.
A list of suitable marker pens can be found on page 3.

WE HAVE TWO KANGAROOS HERE
THE ONE BELOW WE RECOGNISE AS
A KANGAROO BUT IT DOESN'T LOOK
QUITE REAL BECAUSE IT'S A
A CARTOON DRAWING.

HEAD

UPPER BODY

LET'S TRY TO
DRAW A MORE
REALISTIC
ONE —
THESE SHAPES
WILL HELP.

CAN YOU WORK
OUT THE BASIC
SHAPES TO MAKE
THIS ONE?

LOWER BODY

TAIL

DRAWN
LIKE THIS
THE BASIC
SHAPES
START TO
LOOK LIKE
A REAL
KANGAROO

YOU MIGHT LIKE TO TRY
PUTTING SOME SHADING
INTO YOUR DRAWING.

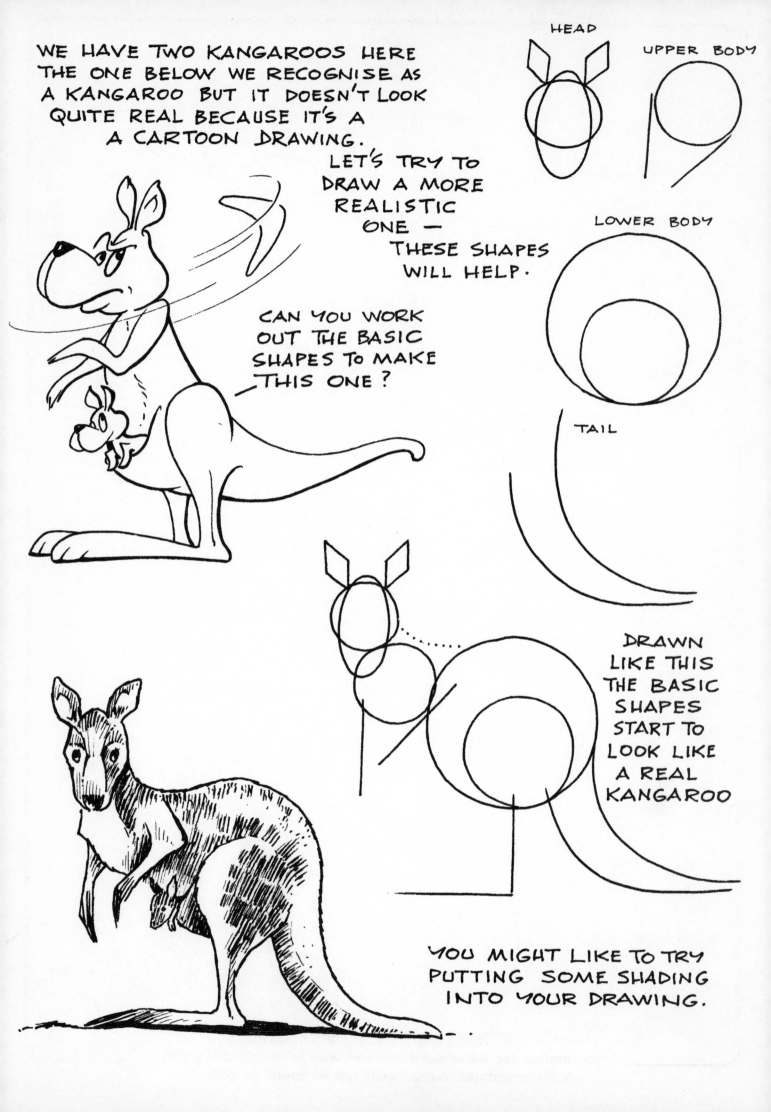

USE THIS PAGE FOR YOUR DRAWINGS
Remember the ink of some markers may penetrate this paper.
A list of suitable marker pens can be found on page 3.

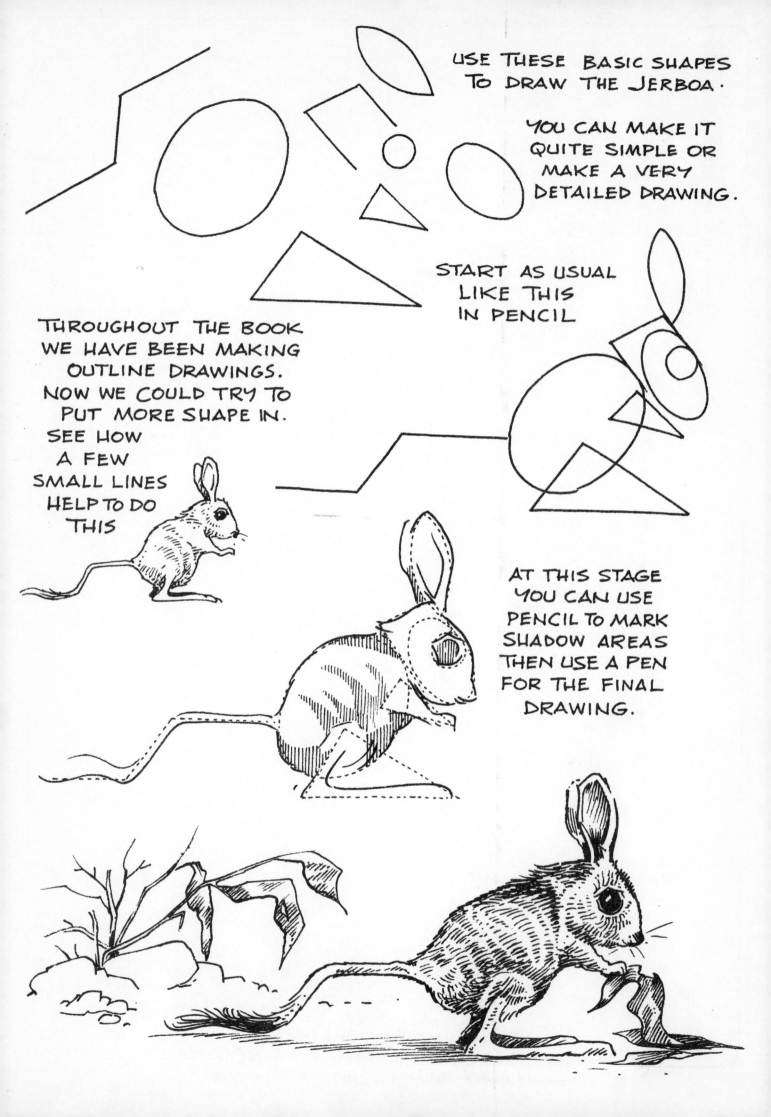

USE THESE BASIC SHAPES TO DRAW THE JERBOA.

YOU CAN MAKE IT QUITE SIMPLE OR MAKE A VERY DETAILED DRAWING.

START AS USUAL LIKE THIS IN PENCIL

THROUGHOUT THE BOOK WE HAVE BEEN MAKING OUTLINE DRAWINGS. NOW WE COULD TRY TO PUT MORE SHAPE IN. SEE HOW A FEW SMALL LINES HELP TO DO THIS

AT THIS STAGE YOU CAN USE PENCIL TO MARK SHADOW AREAS THEN USE A PEN FOR THE FINAL DRAWING.

USE THIS PAGE FOR YOUR DRAWINGS
Remember the ink of some markers may penetrate this paper.
A list of suitable marker pens can be found on page 3.

AS BEFORE, THE BASIC SHAPES
SIMPLIFY THE DRAWING OF
THE BEAR BUT THE END
RESULT LOOKS AS IF A
LOT HAS GONE INTO IT.
IT HASN'T REALLY, THE
BACKGROUND AGAINST
WHICH HE SITS IS ONLY
A TREE AND GRASS WITH
THE SAME AMOUNT OF
BLACK IN THE DESIGN.
TRY IT!

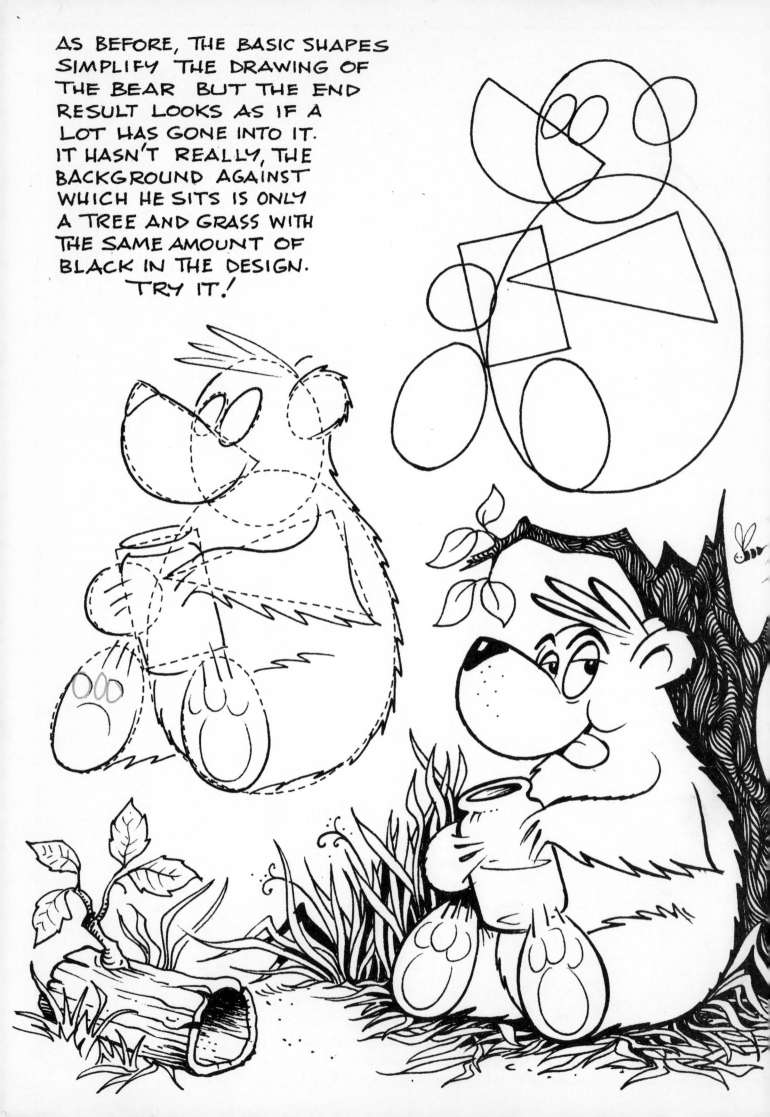

USE THIS PAGE FOR YOUR DRAWINGS
Remember the ink of some markers may penetrate this paper.
A list of suitable marker pens can be found on page 3.

LOOK CAREFULLY AT
THESE SHAPES
THEY DO HELP TO
GIVE YOU THE
CHARACTERISTIC
SHAPE OF A GOAT.

NOW LOOK AT THE
DRAWING AT THE
BOTTOM OF THE PAGE
THAT IS
WE'LL TRY
TO DO.

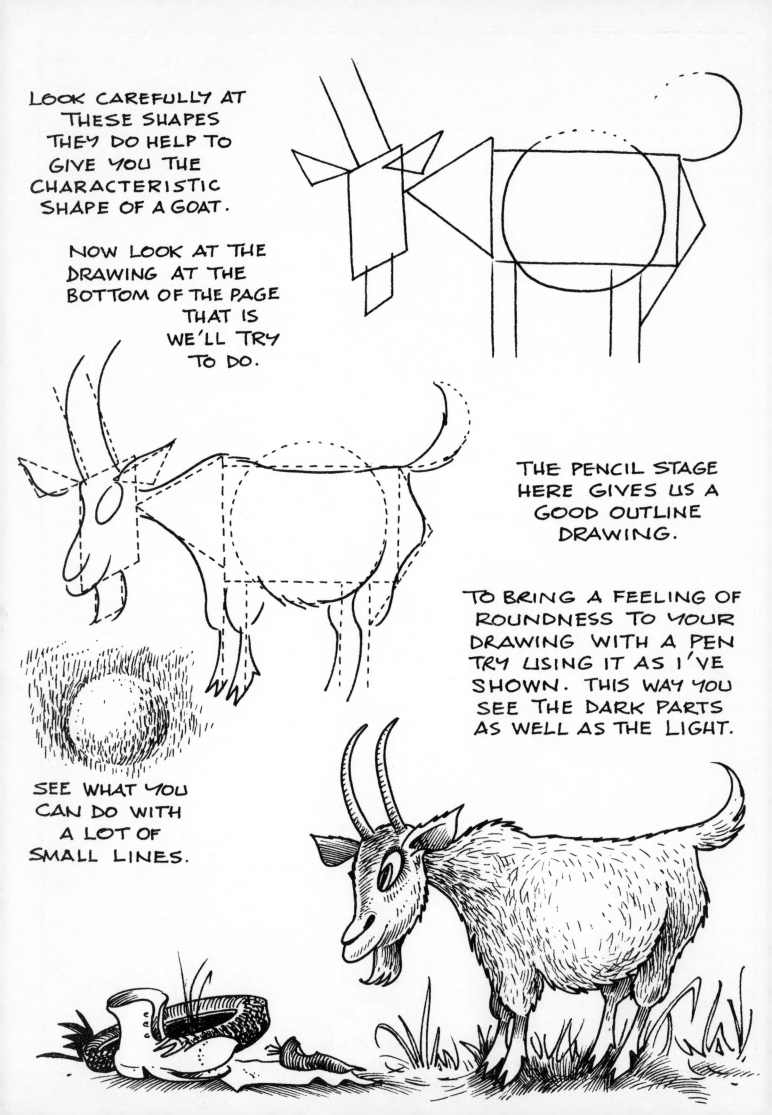

THE PENCIL STAGE
HERE GIVES US A
GOOD OUTLINE
DRAWING.

TO BRING A FEELING OF
ROUNDNESS TO YOUR
DRAWING WITH A PEN
TRY USING IT AS I'VE
SHOWN. THIS WAY YOU
SEE THE DARK PARTS
AS WELL AS THE LIGHT.

SEE WHAT YOU
CAN DO WITH
A LOT OF
SMALL LINES.

USE THIS PAGE FOR YOUR DRAWINGS
Remember the ink of some markers may penetrate this paper.
A list of suitable marker pens can be found on page 3.

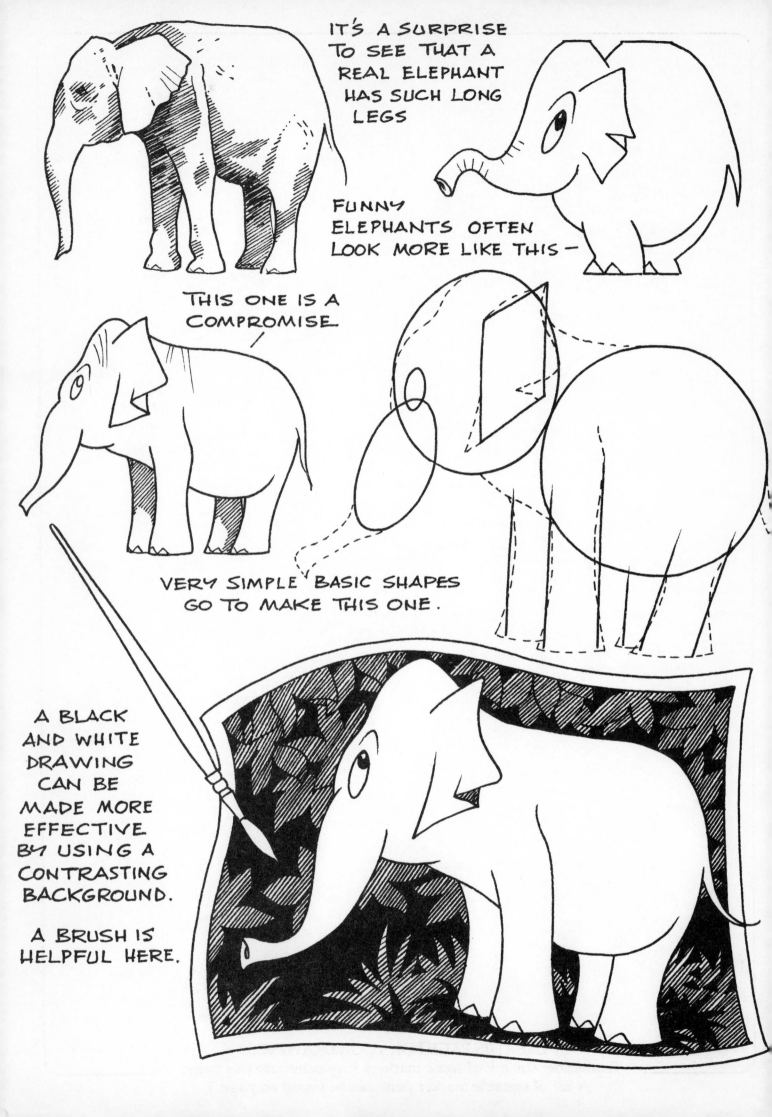

IT'S A SURPRISE TO SEE THAT A REAL ELEPHANT HAS SUCH LONG LEGS

FUNNY ELEPHANTS OFTEN LOOK MORE LIKE THIS—

THIS ONE IS A COMPROMISE

VERY SIMPLE BASIC SHAPES GO TO MAKE THIS ONE.

A BLACK AND WHITE DRAWING CAN BE MADE MORE EFFECTIVE BY USING A CONTRASTING BACKGROUND.

A BRUSH IS HELPFUL HERE.

USE THIS PAGE FOR YOUR DRAWINGS
Remember the ink of some markers may penetrate this paper.
A list of suitable marker pens can be found on page 3.

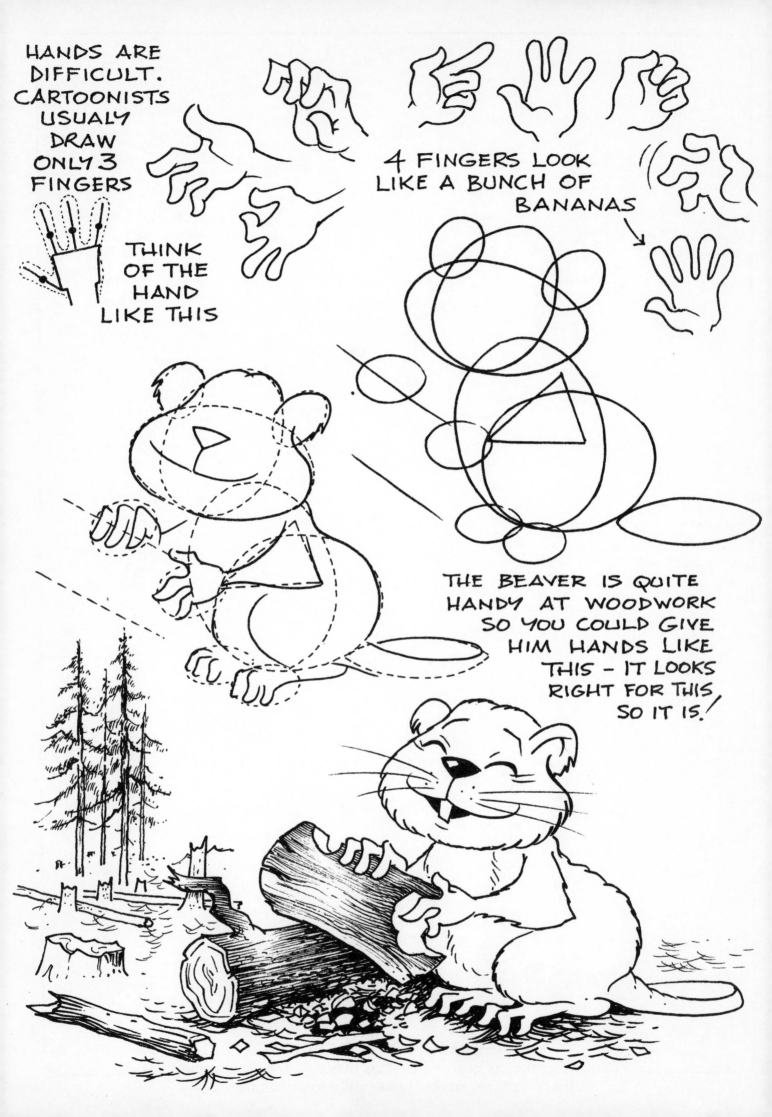

HANDS ARE DIFFICULT. CARTOONISTS USUALY DRAW ONLY 3 FINGERS

THINK OF THE HAND LIKE THIS

4 FINGERS LOOK LIKE A BUNCH OF BANANAS

THE BEAVER IS QUITE HANDY AT WOODWORK SO YOU COULD GIVE HIM HANDS LIKE THIS - IT LOOKS RIGHT FOR THIS, SO IT IS!

USE THIS PAGE FOR YOUR DRAWINGS
Remember the ink of some markers may penetrate this paper.
A list of suitable marker pens can be found on page 3.

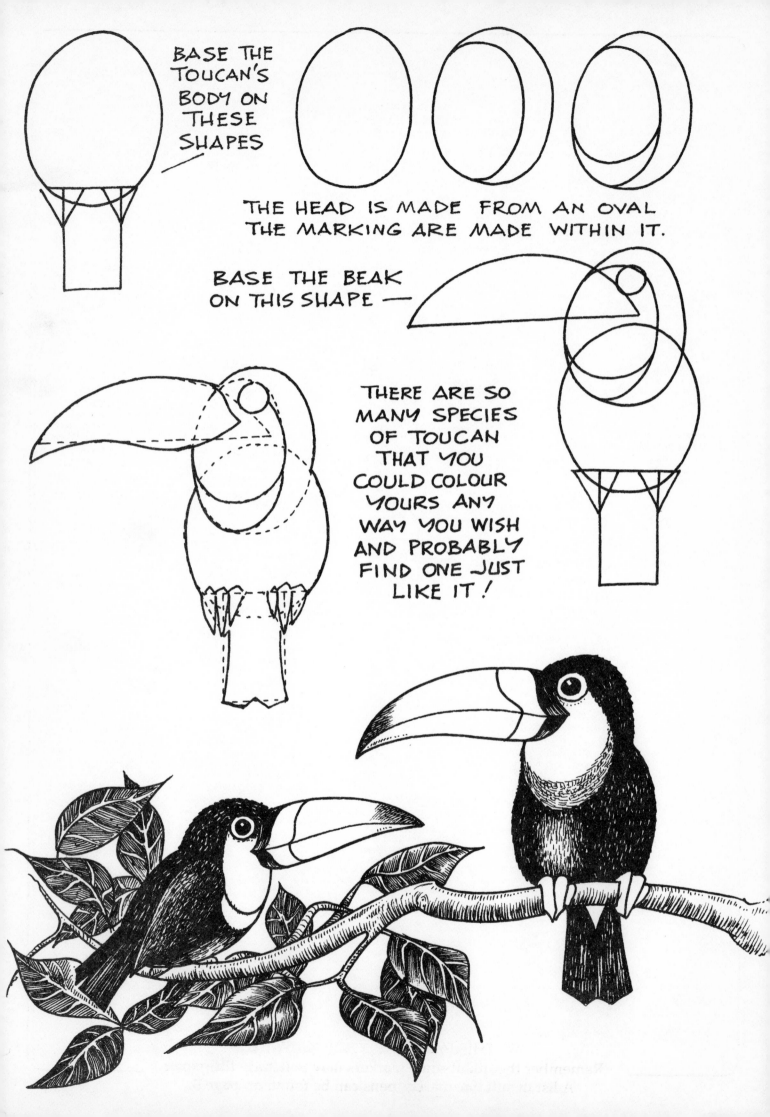

BASE THE TOUCAN'S BODY ON THESE SHAPES

THE HEAD IS MADE FROM AN OVAL THE MARKING ARE MADE WITHIN IT.

BASE THE BEAK ON THIS SHAPE —

THERE ARE SO MANY SPECIES OF TOUCAN THAT YOU COULD COLOUR YOURS ANY WAY YOU WISH AND PROBABLY FIND ONE JUST LIKE IT!

USE THIS PAGE FOR YOUR DRAWINGS
Remember the ink of some markers may penetrate this paper.
A list of suitable marker pens can be found on page 3.

THESE SHAPES MAKE UP THE TIGER. THE DIAMOND SHAPE IS USEFUL IN DRAWING THE HEAD. DON'T THINK ABOUT STRIPES UNTIL YOU'VE DRAWN THE BODY.

AS YOU'VE DRAWN IN PENCIL YOU COULD DRAW IN THE STRIPES LIKE THIS THEN RUB OUT THE PENCIL LINES.

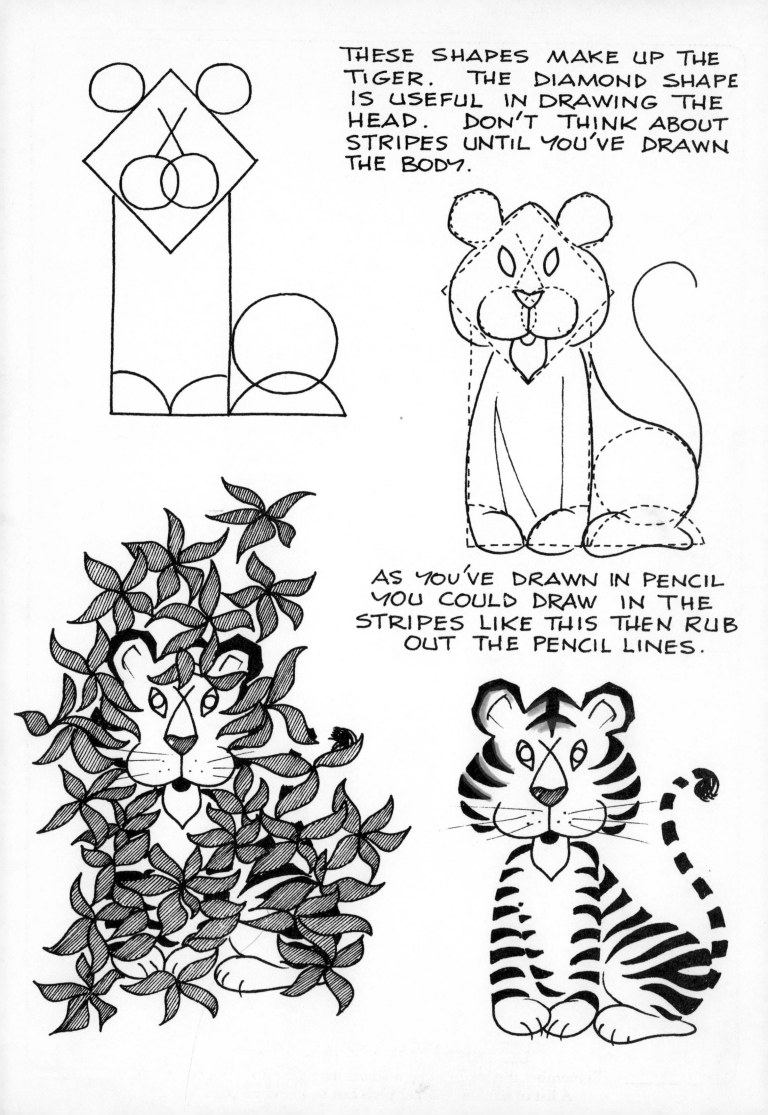

USE THIS PAGE FOR YOUR DRAWINGS
Remember the ink of some markers may penetrate this paper.
A list of suitable marker pens can be found on page 3.

A SPIRAL LIKE THE SNAIL'S SHELL FOR THE TAIL.

THE CHAMELEON IS THAT CLEVER CREATURE THAT CAN SEE IN ALL DIRECTIONS AT ONCE, CHANGE COLOUR AND CATCH FLIES!

YOU WILL ALSO FIND HIM ON THE COLOUR SECTION OF THE BOOK. YOU MAY WANT TO CHANGE THE COLOURS.

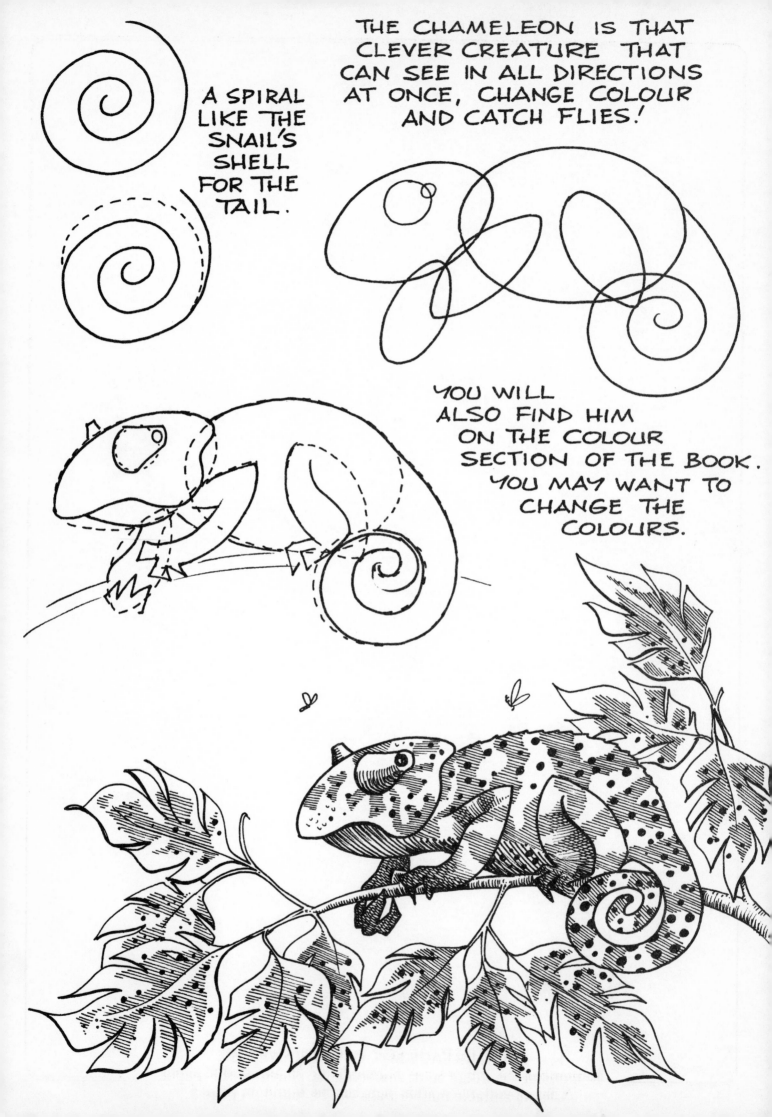

USE THIS PAGE FOR YOUR DRAWINGS
Remember the ink of some markers may penetrate this paper.
A list of suitable marker pens can be found on page 3.

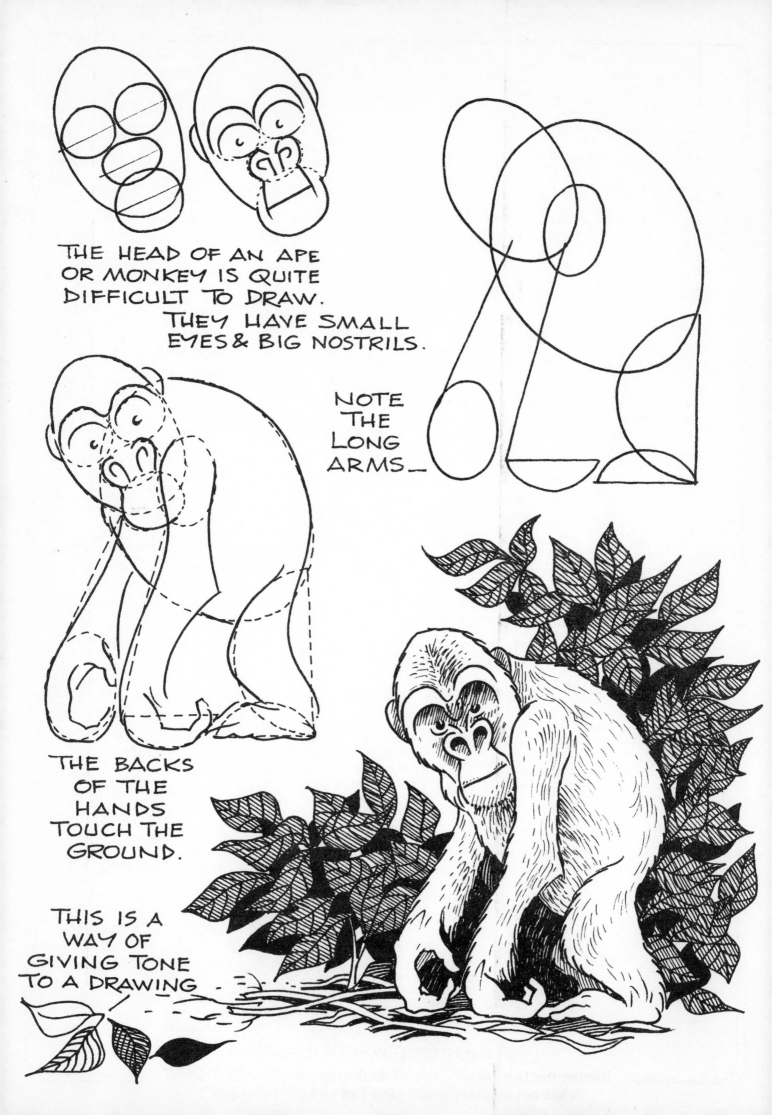

THE HEAD OF AN APE
OR MONKEY IS QUITE
DIFFICULT TO DRAW.
THEY HAVE SMALL
EYES & BIG NOSTRILS.

NOTE
THE
LONG
ARMS_

THE BACKS
OF THE
HANDS
TOUCH THE
GROUND.

THIS IS A
WAY OF
GIVING TONE
TO A DRAWING

USE THIS PAGE FOR YOUR DRAWINGS
Remember the ink of some markers may penetrate this paper.
A list of suitable marker pens can be found on page 3.

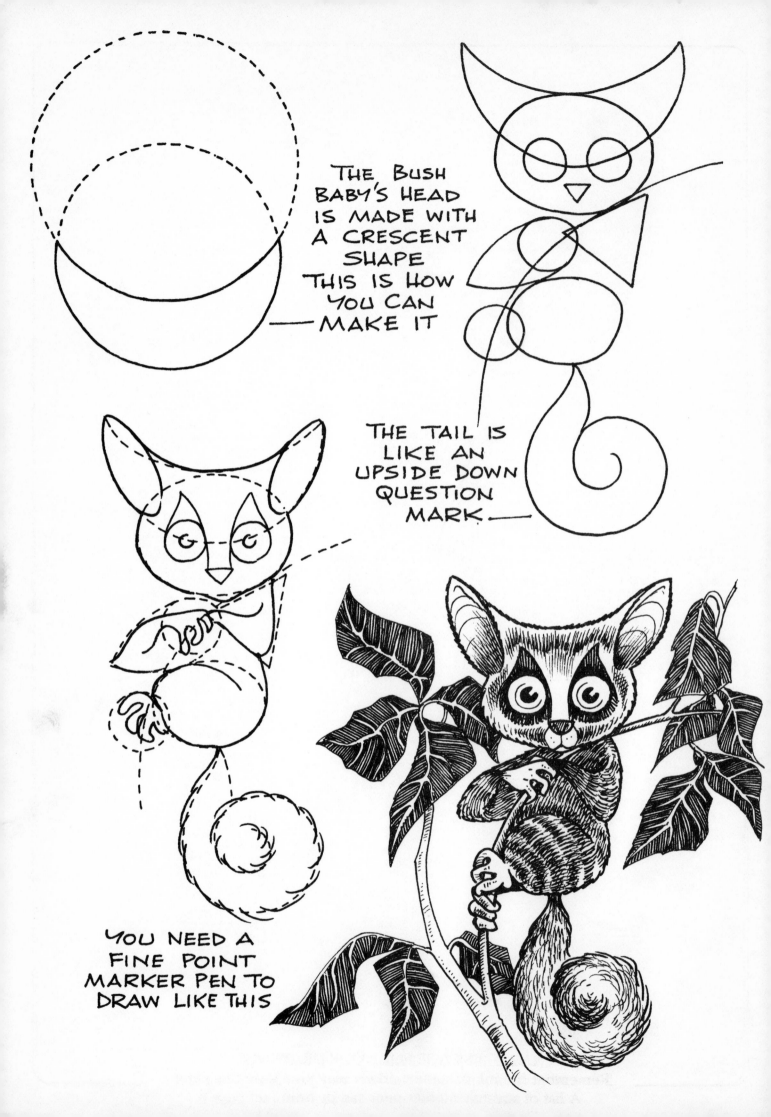

THE BUSH BABY'S HEAD IS MADE WITH A CRESCENT SHAPE THIS IS HOW YOU CAN — MAKE IT

THE TAIL IS LIKE AN UPSIDE DOWN QUESTION MARK. —

YOU NEED A FINE POINT MARKER PEN TO DRAW LIKE THIS

USE THIS PAGE FOR YOUR DRAWINGS
Remember the ink of some markers may penetrate this paper.
A list of suitable marker pens can be found on page 3.

THE FOX & THE CROW

SHAPES
TO HELP YOU DRAW
THE CROW

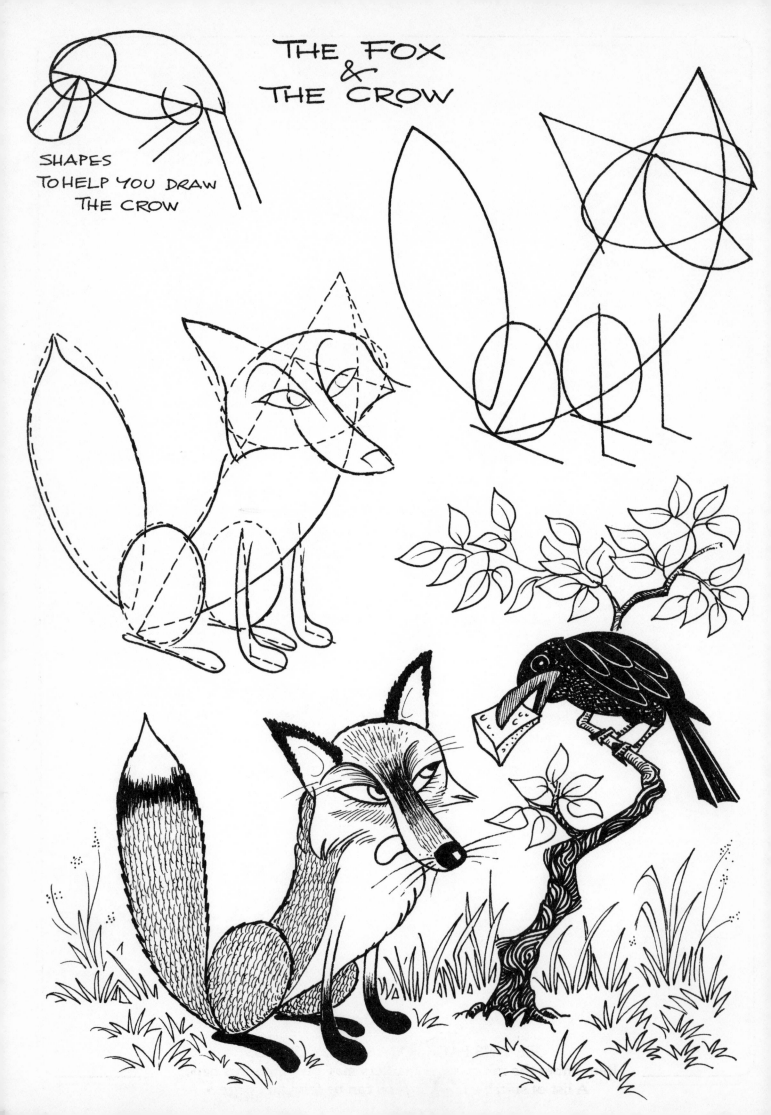

USE THIS PAGE FOR YOUR DRAWINGS
Remember the ink of some markers may penetrate this paper.
A list of suitable marker pens can be found on page 3.

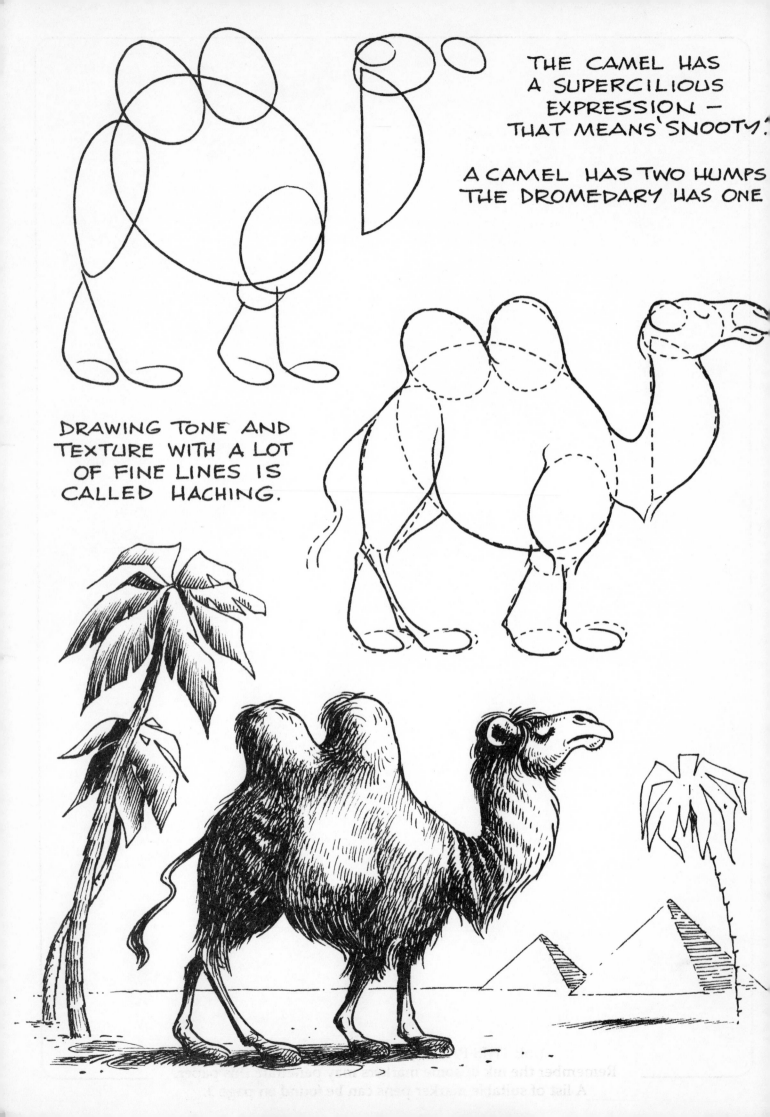

THE CAMEL HAS A SUPERCILIOUS EXPRESSION — THAT MEANS 'SNOOTY'.

A CAMEL HAS TWO HUMPS THE DROMEDARY HAS ONE

DRAWING TONE AND TEXTURE WITH A LOT OF FINE LINES IS CALLED HACHING.